THE
TOTEM POLES
OF
STANLEY PARK

VICKIE JENSEN

For Bill —
Wishing you a
complete and speedy
recovery!...
Vickie
Jensen

Westcoast Words
3036 Waterloo Street
Vancouver, B.C. V6R 3J6 Canada
www.westcoastwords.com

in association with

Subway Books Ltd.
1819 Pendrell Street, Unit 203
Vancouver, B.C. V6G 1T3 Canada
www.subwaybooks.com

National Library of Canada Cataloguing in Publication
Jensen, Vickie, 1946–
 The totem poles of Stanley Park / Vickie Jensen.

 Includes bibliographical references.
 ISBN 0-9687163-8-5

 1. Totem poles—British Columbia—Vancouver. 2. Indian wood-carving—Northwest
Coast of North America. 3. Indians of North America—Northwest Coast of North America.
4. Stanley Park (Vancouver, B.C.) I. Title.
E98.T65J447 2004 731'.7 C2004-900132-9

Cover photograph: Al Harvey/slidefarm.com
Totem poles illustrations: Hilary Stewart
Northwest Coast Native art illustrations: Norman Tait with Lucinda Turner
Maps: Nola Johnston
Photographs: Vickie Jensen unless otherwise credited
Editing: Mary Schendlinger
Cover design, text design and page composition by Martin Nichols, Lionheart Graphics
Production: Peter Robson
Printed and bound in China by Prolong Press

Acknowledgements

- Hilary Stewart and Douglas & McIntyre,
 for permission to reprint totem pole drawings
- Dr. Jean Barman for sharing research on Park history and squatters
- Randy Bouchard and Dr. Dorothy Kennedy,
 for information on early Squamish history in Stanley Park
- Terri Clark, Communication Coordinator,
 Vancouver Board of Parks and Recreation
- Dr. Andrea Laforet, Nadja Roby and Louis Campeau,
 Canadian Museum of Civilization
- U'Mista Cultural Centre for use of V. Jensen photos on pp. 4(top), 10,
 11(bottom), 18, 22(top), 26(bottom), 48, 52, 57, 58, 61
- Vancouver City Archives
- Vancouver Public Library
- Jewish Historical Society

Thanks to Robert Barratt, Doug and Vivian Cranmer, Beau Dick, Terri Dick and
Geri Dick, Lyn Guy, Al Harvey, Bruce Jackson and Sue Battin, Tim Paul, Norman Tait
and Lucinda Turner, Gloria Cranmer Webster, Don Yeomans and always to Jay Powell

Northwest Coast Native Cultures

Land of Sea and Cedar

THE NORTHWEST COAST has been home to Native peoples for thousands of years. The rich bounty of the sea and the temperate rain forests shaped their lives and cultural activities. Abundant runs of salmon and other seafood made fresh food readily available. Giant trees, particularly the cedar, provided materials for their needs—large plank houses, totem poles, canoes, ceremonial masks, clothing, baskets, tools and utensils.

Aboriginal people lived in tune with the cycles of nature—hunting, fishing and gathering foods as they came in season. During the long winter days and nights they had time to develop a rich artistic and ceremonial life. Some specialized in weaving, painting or carving totem poles and other objects. They held lavish ceremonies in which dancers wore elaborately carved masks and regalia.

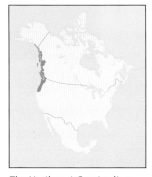

The Northwest Coast culture is cut off from the rest of the world by the Pacific Ocean on the west and by high mountains on the east. It stretches from northern California to the Alaska panhandle.

Native Bands

All Native groups in the Northwest Coast culture area relied on the sea and cedar for their needs, and all practised some form of the potlatch, a ceremonial feast to mark special occasions. But the groups differed in language, kinship, carving styles, rituals and other cultural practices.

WHICH WORD IS CORRECT?

Until recently, the term "Indian" was used for all aboriginal people. Today the terms "Native," "indigenous people," "First Nations" and "aboriginal people" are more commonly used as general terms in Canada. Of course, Native people also draw their identity from the distinct group they belong to, so an aboriginal person might tell you that he is Heiltsuk. Another might say that her mother is Nuxalk and her father is Sto:lo.

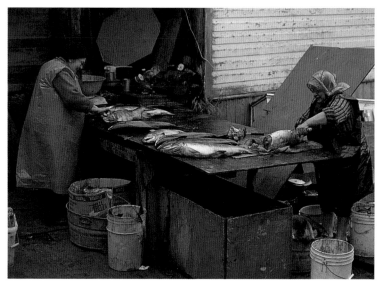

On the Northwest Coast, salmon has been a central feature of indigenous cultures for thousands of years. These women are preparing fish for canning.

In Canada, aboriginal peoples have been organized into political units known as Native "bands," each of which is governed by its own elected council. These can comprise one or more villages. A Native group may also call itself a "Nation." In the United States a similar group is called a "tribe."

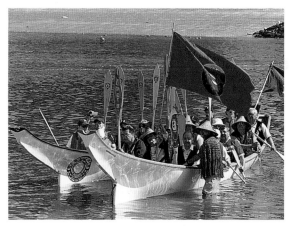

Paddlers in one of the Squamish Nation canoes and an RCMP canoe approach a Vancouver beach, waiting to be ceremonially welcomed and invited to come ashore.

The House Unit

Before the arrival of Europeans, related families lived together in large communal cedar plank houses called longhouses, bighouses or community houses. Each of these permanent structures could house 40 to 60 people. During the summer, smaller family groups would leave to hunt, collect seasonal foods, or catch and preserve fish.

These large households were the basic social

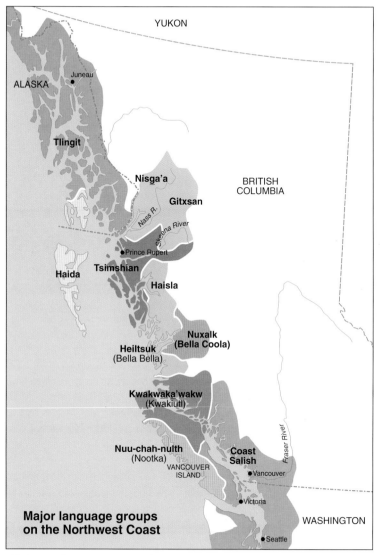

Major language groups on the Northwest Coast

All aboriginal groups on the Northwest Coast have many cultural features in common, but each has its own language, as shown here. Groups such as the Coast Salish actually encompass several distinct language communities, including the Squamish and Halkomelem of the Vancouver area. In recent decades, many aboriginal groups have reclaimed traditional names or taken new, more appropriate ones. For example, the Nuu-chah-nulth people were called "Nootka" for several centuries, because Captain Cook misunderstood the term Nootka, thinking it was what the Natives called themselves. Similarly, "Kwakwaka'wakw," meaning "the people who speak Kwak'wala," is more accurate than the old term, "Kwakiutl," which refers to only one group of Kwak'wala speakers.

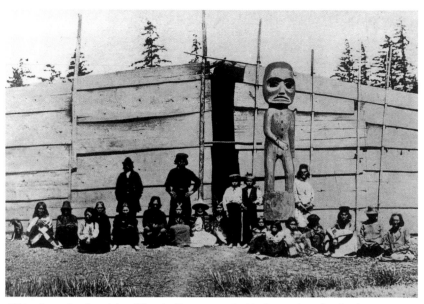

Although construction styles differed, all groups on the Northwest Coast lived in large communal cedar plank houses that faced the water. This Salish longhouse was located in Comox.
P. Timms photo, Vancouver Public Library VPL 12817

unit on the Northwest Coast. One or more of the houses made up a village. Each house had its own oral histories and ceremonial possessions. High-status individuals in some households also held rights to certain resource sites, such as fishing, hunting or berry-gathering grounds. Each house was politically independent, conducting its own affairs under the direction of its leader, although some chiefs had higher status than others.

Every aspect of Northwest Coast life reflected a social hierarchy. In many groups, people could inherit names that carried privileged positions, high status, authority and rights. These nobles had hereditary authority to manage the group's activities. Most people were commoners. Groups also had slaves who had been captured in raids on other coastal peoples.

Men and women worked according to their gender and rank. Men were the fishermen and hunters; women picked berries, harvested shellfish and gathered root vegetables and other plants, as well as preserving and preparing foods. People of both sexes were artisans, but men designed, carved and painted objects—including totem poles—while women wove baskets, mats and clothing. Particularly skilled artists had great prestige and earned extra privileges.

Opposite: As this early photo of Alert Bay shows, more northerly Native houses often featured painted housefronts or totem poles that announced the ancestry of the residents. City of Vancouver Archives, S9N 1109

Family Histories

Like all cultures, the Northwest Coast groups have their own myths and legends to explain how things came to be and how people ought to act. These important stories continue to be told and retold from generation to generation.

Some legends belong to everyone; others belong to a particular family. Many of these mythic histories tell how the family acquired its clan or crest figure, usually because of an early encounter with a supernatural creature. As a result, in some parts of the Northwest Coast, the family has the inherited right to tell those stories and to carve and paint those ancestral figures on totem poles, housefronts, masks, canoes and other objects.

Winter Ceremonials

Lavish winter ceremonials called potlatches, or simply "feasts," were an important part of Northwest Coast culture. The potlatch was a way for significant events such as a memorial, name giving, marriage or totem pole raising, to be recorded in the memories of important people. By giving a potlatch, a chief and his family displayed their wealth, fulfilled their obligations and rose in status.

Coastal indigenous peoples developed a wide variety of fishing techniques, using weirs, nets, lures and spears. Today, most fishing is done with high-powered gillnetters or seine boats.

When invited guests arrived for the potlatch, they were seated inside the longhouse, each according to his or her rank. The host family usually opened the event by giving speeches, then presented the dances, songs, carved masks and regalia that they had a right to use. They would also feed the assembled guests. Some feasts lasted for days. At the end, each person received a "gift" that was actually payment for witnessing the event. The amount of this payment reflected the guest's importance, as well as the status of the family giving the potlatch.

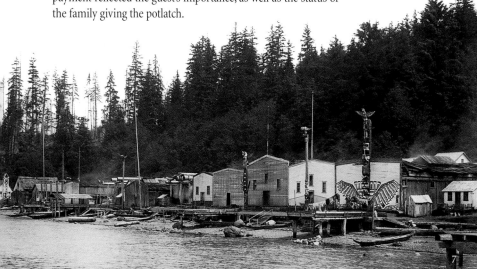

Old Ways, New Ways

Today, Northwest Coast Native peoples dress, live, work and play as most other British Columbians do. However, the change from the "old ways" to modern times has been far from easy. When coastal aboriginal people began trading goods with Europeans in the late 18th century, they acquired new foods, fabrics and efficient iron tools. But they also got alcohol, guns and epidemic diseases, with dire results.

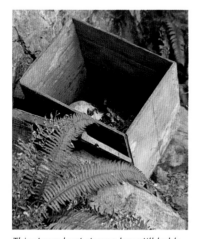

This steam-bent storage box still holds the bones of the deceased. Such traditional above-ground burial practices slowly gave way to the in-ground burials advocated by missionaries.

Historians estimate that as many as 90 percent of Natives living in B.C. may have died from small-pox, measles, sexually transmitted diseases and other illnesses, as well as alcoholism and despair. Many coastal villages were deserted by the late 1800s, their houses and totem poles fallen into disrepair.

Aboriginal people also felt the forceful influence of missionaries and government officials, who enacted laws and policies designed to hasten their assimilation into the "whiteman's" way of life. Generations of Native children were taken from their families and sent to residential schools run by missionaries and funded by the federal government. They grew up far from home, forbidden to speak their own languages and cut off from the traditions and teachings of their elders. Native people did not even have full voting rights in B.C. until 1949, and were finally allowed to vote in federal elections in 1960.

The Land Question

A clash between Native peoples and those who came to colonize was inevitable. In most cases land was simply appropriated by the newcomers, and few treaties were ever signed in British Columbia. In 1990, the province finally agreed to work with the federal government and settle the land question. Many First Nations groups began the lengthy process of submitting formal statements of intent to negotiate treaties.

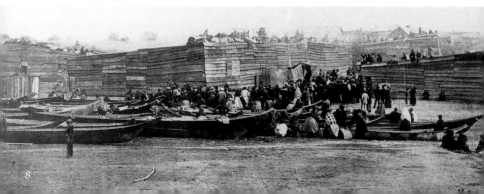

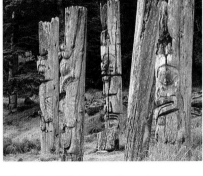

As indigenous villages were decimated by various epidemics, survivors moved elsewhere. Deserted houses and totem poles were quickly reclaimed by the damp coastal climate. Haida village of Ninstints (Anthony Island) in the Queen Charlottes.
Photo by Al Harvey/slidefarm.com

The first modern treaty was signed with the Nisga'a in 1999.

Today about 156,000 Native people live in British Columbia, just under 4 percent of the total population of the province. Most aboriginal people still feel strong ties to the land of their ancestors, even those who live in towns and cities. Only a quarter of the indigenous population live on Native reserves, parcels of land set aside by the federal and provincial governments for Native use and occupancy.

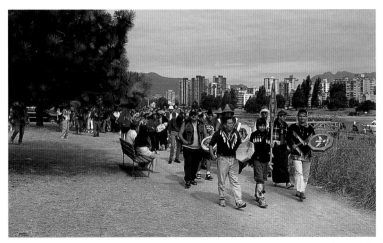

The Squamish celebrate the return of a 10-acre piece of reserve land near the south end of the Burrard Bridge that had been expropriated by the Canadian Pacific Railway in 1886.

The Potlatch

Many early missionaries and government officials were convinced that the potlatch undermined their goal of bringing Native peoples into mainstream civilization. In 1884 the federal government of Canada actually outlawed the potlatch. Ceremonial masks and regalia were confiscated; some chiefs and dancers were even jailed. Master carvers stopped training apprentices because there was little call for their work.

Opposite: This Coast Salish potlatch in Nanaimo drew a large gathering of Natives in 1870. Vancouver Public Library, VPL 12862

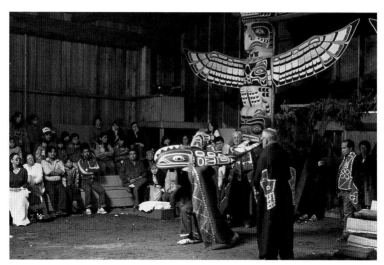

The Kwakwa̱ka'wakw continue their strong potlatching tradition. Families may save for years in order to commission new masks, make regalia and amass the cash and goods that will be handed out.

Fortunately some artists kept carving, and a few families continued potlatching in secret. Finally, in 1957, the potlatch prohibition was simply dropped from the books. Today new longhouses are being built for ceremonial events, and many Native families host a potlatch ceremony—or feast, as some call it—to mark important events such as a memorial, a marriage, the inheritance of a name or the raising of a new totem pole.

Chiefs, dignitaries and guests gather to celebrate the opening of the new bighouse in Alert Bay.

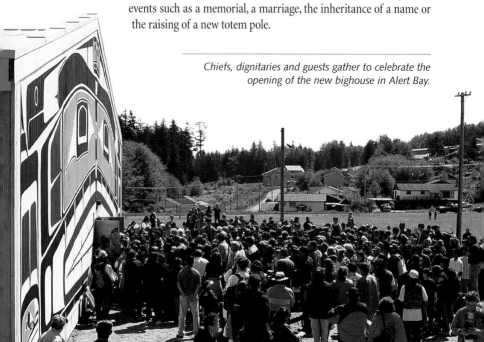

Cultural Revival

In spite of almost two centuries of official programs and policies to assimilate aboriginal people into the dominant culture in the Northwest Coast, Native beliefs and traditions have survived. Today, many British Columbia First Nations are engaged in treaty negotiations and steps toward self-government. Children and adults are studying the traditional languages and dances, and taking part in time-honoured ceremonies. Indigenous communities are once again carving and paddling their great canoes. The popularity of the totem poles of Stanley Park reflects a growing worldwide interest in the revival of Northwest Coast Native art and culture.

Some schools, such as this one in Kispiox, have created their own books to teach the Native language and culture.

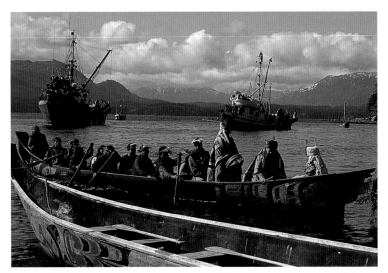

Many coastal communities have participated in the Native canoe revival, building and paddling great canoes as they affirm their pride and identity. In this photo, canoes full of paddlers and chiefs lead seine boats, each of which carries dancers from various Kwakwaka'wakw villages.

Totem Poles

TOTEM POLES ARE CARVED HISTORY. The figures on a traditional pole depict the ancestry or accomplishments of a particular chief or family, or record a clan's history.

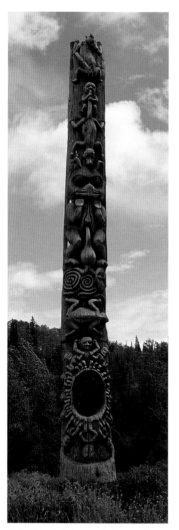

Some poles serve as symbols of inherited rights and privileges. Others illustrate stories or real-life events.

Carving a pole involves a tremendous commitment, so these massive cedar monuments have always been highly valued and respected in aboriginal cultures. Perhaps that's why totem poles have such a mystical presence—even for people who know little about them.

The First Poles

Northwest Coast Native peoples have been carving wood for a long, long time—at least 5,000 years, according to archaeological evidence! Surprisingly, totem poles are a fairly recent development in this long, evolving tradition of art.

No one knows exactly when or where the first poles were carved, but we do know that the first European explorers who came to the northern Pacific coast in the late 1700s saw totem poles. In fact, some of the sailors and draftsmen on those voyages drew pictures of the interior house posts and doorway poles they encountered. Ships' captains occasionally mentioned these immense carvings in their ship's logs or private journals, but infrequent references to the poles suggest that they were not numerous.

This historic totem pole from Kitwancool is known as Place-of-Opening or Hole-through-the-Sky. The 17 figures so skillfully carved on the pole depict how the family received the right to display the Wolf-pack-migrating crest.

More Poles, More Troubles

When Native people began to trade with the Europeans in the early 1800s, totem pole carving practice changed quickly, in two significant ways. First, sea otter pelts were so valuable that chiefs who traded them became much more wealthy, and could afford to commission the carving of more totem poles. Second, the traders brought iron tools, and these prized barter items greatly speeded up the carving process. The result was a dramatic increase in the number and quality of totem poles. Early black and white photographs show northern coastal villages fairly bristling with poles. This "golden age of totem pole carving" lasted until the 1860s.

But at the same time, aboriginal people all along the coast had to withstand the impact of disease and alcoholism, as well as the active undermining of Native culture. For example, missionaries did not understand the system of clans and crests; some thought that Natives actually worshipped totem poles and urged that the poles be

Totem poles deserve your respect. Please do not deface or climb on them. Take time to study the poles and see what lessons there are to be learned.

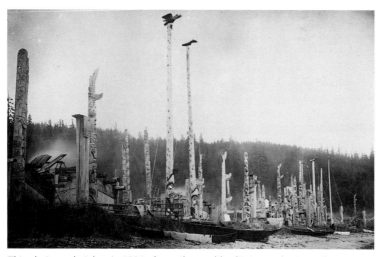

This photograph, taken in 1884, shows the wealth of totem poles in northern coastal villages like Skidegate on the Queen Charlotte Islands.
Richard Maynard photograph, BC Archives, 9078

cut down. Many politicians and others in positions of authority believed that indigenous cultures were dying out and enacted policies to bring Native people into the "whiteman's" way of life. The Potlatch Prohibition of 1884 outlawed these important ceremonies, so many aging master carvers quit training young apprentices.

The great museums of Europe and America feared that they had seen the last Northwest Coast art. So from the 1870s to the 1920s, there was fierce competition to acquire the last of the "good" ethnographic artifacts. In fact, it was during this period that the first Stanley Park poles were purchased.

By the 1920s, totem poles had already become symbolic of the Northwest Coast region and a source of fascination for many people. In 1925 the Canadian government and Canadian National Railway (CNR) launched a restoration project for the remaining poles along the Skeena River, citing their appeal to tourists. Similar projects were initiated in the 1930s and '40s in Alaska.

The Renaissance of Native Art

In the 1950s, the Museum of Anthropology at the University of B.C. in Vancouver and the Royal British Columbia Museum in Victoria made the unprecedented decision to repair or replicate old and decaying poles. The Museum of Anthropology hired Ellen Neel and Mungo Martin, both Kwakwaka'wakw carvers. Martin brought in apprentices to assist with the work. Over the years, a number of young carvers who worked on projects at both of these museums went on to become masters themselves: Henry Hunt and his son Tony, Bill Reid, Doug Cranmer, Robert Davidson, Norman Tait, Joe David and, in Alaska, Nathan Jackson.

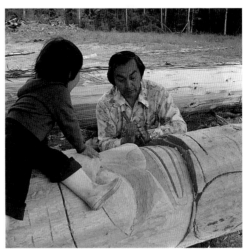

Left: Many aboriginal people are working on new ideas for regalia—from sewing button blankets to weaving cedarbark capes or Chilkat blankets; right: Gitxsan artist Walter Harris knows that an awareness of carving comes at a tender age for family members.

Elsewhere in British Columbia, other community and Native groups took up the challenge of restoring old poles and reviving the carving tradition. Today a new generation of artists is carving masks, fashioning regalia and carving totem poles and other massive sculptures, as well as creating new art forms such as silkscreen prints. Once again, Northwest Coast art is being collected around the world.

Types of Totem Poles

In traditional times, a chief might commission a totem pole for any one of a variety of reasons. He might have inherited a name and rights from a deceased chief, which would incur an obligation to raise a pole to that chief's memory. Or he might decide to build a new longhouse with carved house posts that depicted the family's mythic history. Or he might want to have a figure carved that would welcome guests arriving at a potlatch. Whatever the reason, often the chief would pay someone of another clan to do the carving. When finished, the pole was usually raised in conjunction with a lavish feast or potlatch ceremony.

The type and use of totem poles varied from group to group. For example, Coast Salish artists carved interior planks and grave figures but not free-standing poles. Gitxsan carvers produced memorial totem poles but not welcome figures.

The different types of totem poles are:

- **interior house posts**, which held up the massive beams of longhouses or large **carved planks** attached to the inside or outside of ceremonial dance houses

- **house frontal poles**, or portal poles, which served as doorways

- **mortuary poles**, which might hold the remains of a chief or high-ranking person in a cavity at the top

- **free-standing memorial poles**, erected in memory of a chief

- **free-standing interior poles**, which were occasionally placed at the back of a high-ranking chief's house

- **grave figures**, which were carved and erected in memory of a deceased chief, or other **carved spirit figures** that were part of the coast peoples' ceremonial life

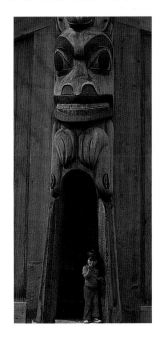

This doorway pole is part of the reconstructed Gitxsan village of 'Ksan, in Hazelton, B.C.

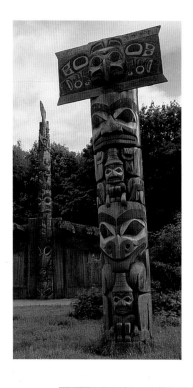

Mortuary poles contained the remains of the deceased, often in a box that was part of the pole.

- **welcome figures,** which welcomed important guests arriving for a potlatch or other feast, and

- **shame poles or figures,** which were erected occasionally to ridicule another chief or family for improper behaviour.

Totem poles, as most people know them, started among the most northern aboriginal groups: the Tlingit, Haida, Tsimshian and Kwakwaka'wakw. Until the late 1800s, there were few free-standing totem poles in the central and southern Northwest Coast area. Over time this changed, and today carvers from all groups produce various types of poles.

Totem poles continue to evolve in other ways. In recent decades two new types of carvings have come into prominence:

The massive Raven and the Clamshell sculpture illustrates the Haida creation myth that explains how people came to be.

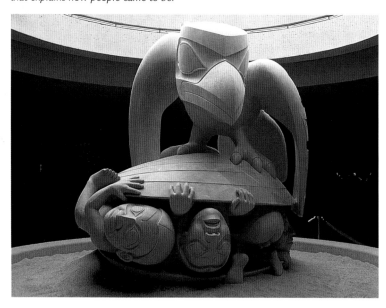

- totem poles carved for non-Native organizations, such as museums, corporations, shopping malls, even parks, and

- massive free-standing totemic "sculptures" (such as Bill Reid's Raven and the Clamshell at the UBC Museum of Anthropology).

These new forms still feature crest figures and are based on Native legends, but they are usually commissioned by organizations that have no mythic ancestry themselves. Such modern poles possess a strong symbolic identity rather than a traditional one.

The Figures on the Poles

It is often said that anyone can "read" a totem pole if they can recognize the figures carved on it. In fact, no one can do that unless they already know the myth that the carving portrays. For those who know that myth, the carved crest figures serve as a

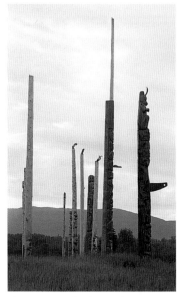

These memorial poles are from Kispiox.

memory prompt for the story. Many of these stories are family property, so they may be told at the pole-raising ceremony. Other more general Northwest Coast legends have been written down in books in English and other languages.

To fully understand a particular totem pole, one must also know something about the people who commissioned the pole and carved it, as well as the circumstances of the creation of the pole, such as the reason it was ordered. Traditionally, a chief would tell the artist which crests

This photo of a Fraser River grave site with various grave figures was taken in the 1860s.
Vancouver City Archives, A-6-175

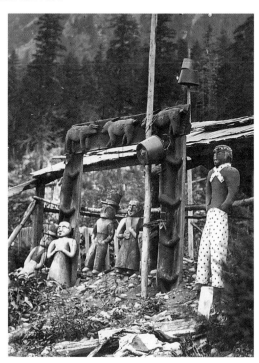

to put on the pole, but the carver could choose how to portray them. When a museum, corporation or other entity that has no Native ancestry commissions a pole, the artist will often select a myth that seems appropriate and carve figures from that story as well as creatures that relate to the event or organization.

Many aboriginal artists also include hidden meanings and visual puns in their designs, so it may not be possible to know everything that's going on in a pole design unless you've spoken with the carver. Even if we don't know the entire story of a totem pole, it's still enjoyable to learn to recognize the figures carved on it. The key is the identifying characteristics of the various creatures (outlined in detail on pp. 50–61).

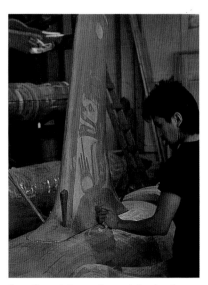

Sometimes totem poles contain visual puns. The carved hand on the other side of Whale's fin is perfectly normal, but the fingers on this side have been shortened so it's giving "the finger."

The Making of Totem Poles

Cedar

The dense forests of the Northwest Coast produced abundant red cedar. Native peoples referred to this tree as "Long Life Maker" because its wood, bark, withes (secondary branchlets) and roots were all used to sustain their life. The tall, straight trunk provided

The cedar tree provided a range of materials that looked after indigenous people, literally from cradle to grave—from a baby's woven cradle basket to a steam-bent burial box.

the clean-splitting wood that carvers sought for totem poles, canoes, house beams, large masks and steam-bent storage boxes. Women fashioned the inner bark into baskets, mats, ropes and clothing. The withes were used to make heavy-duty rope or work baskets, and for lashing. Cedar roots made good, tough coil baskets. Appropriately, the Latin name for red cedar is arbor vitae or "tree of life."

Red cedars grow from northern California, along the coast of Oregon and British Columbia up to Sitka, Alaska. In some areas of the Queen Charlotte Islands, there are first-growth cedars towering to heights of 70 m (230 ft) and estimated to be a thousand years old! Both the wood and the inner bark are made up of many layers, providing strength and flexibility. Mature red cedar wood contains a toxic oil that gives the cedar its characteristic scent and preserves the wood, making it resistant to insects and fungi even after the tree has fallen or been cut down. Nonetheless, because of the damp climate of the Northwest Coast, most totem poles only last for 70 to 100 years, depending on their exposure to sun, rain and wind.

Today, cedar trees of sufficient size for carving a totem pole are found in only a few old-growth forests. The second- and third-growth trees of replanted forests are still centuries away from a suitable height and girth. Farmed trees also grow very fast, so the grain is not tight enough for good carving.

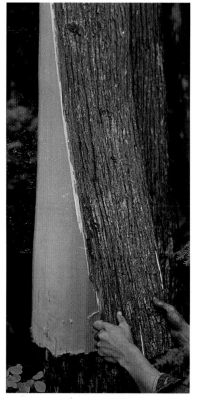

Stripping the bark off a cedar tree does not permanently harm the tree. The wound eventually scars over, leaving a "culturally modified tree," or CMT, as testimony to earlier aboriginal use of the area.

In earlier times, a carver or canoe maker might ritually purify himself and pray for help in choosing the right tree. He would thank the tree respectfully for presenting itself. Then came the laborious work of falling the tree, either by controlled burning or by cutting the massive trunk with adzes. Either way, many workers (often slaves) were required. Carvers might rough out the shape before skidding the log out of the forest and down to the water, where it could be towed to the village.

Today's carvers have it much, much easier! When a totem pole is commissioned, the master carver usually informs a timber company of the size requirements he needs and asks them to be on the lookout for a suitably large old-growth tree with straight grain, minimal tree rot and as few knots as possible. He also specifies when and where the log should be delivered.

Carving

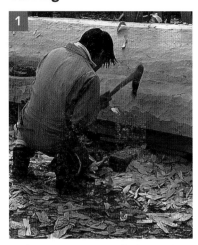

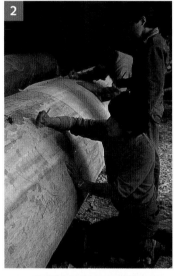

1. *For a contemporary totem pole, a suitable log is brought to the carving site and the bark is taken off. Most artists remove a third to a half of the back of the tree; some cut a trough or "cove" to relieve the tight, pressurized wood in the centre. Then the carvers use their big adzes to cut away all the outer sapwood, smoothing and rounding the log in the process. When only the red "heartwood" remains, the log is ready to carve.*

2. *The master carver usually designs the pole by drawing small-scale front and side views on tracing paper, and sometimes by carving miniature versions of the pole. The design is transferred onto the log, and the figures may be adjusted to fit better.*

3. *Once he is satisfied with the look of the drawing, the master carver uses a chainsaw to make the first rough cuts in shaping the major figures. Then the crew members refine those cuts with their adzes. Carvers often refer to this process of blocking out and cutting the major creatures as "roughing the pole."*

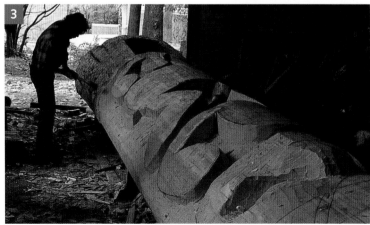

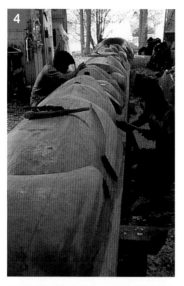

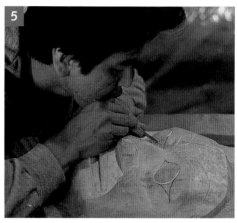

4. The next stage, sometimes called "rounding the pole," begins when the carvers use smaller adzes, chisels and knives to give the figures a more sculptural look. For example, arms and legs that were squared off and blocky begin to look rounded and realistic.

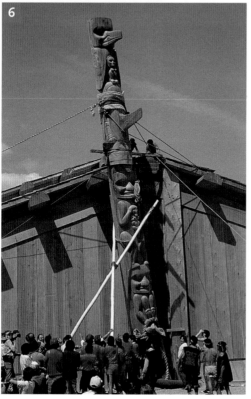

5. During the finishing stage, the crew works with still smaller adzes to give a uniform finish to the wood. With a variety of curved and straight knives, they complete detail work on the eyes, nostrils and teeth. If a totem pole is to be painted, the carvers begin that work once all the carving is finished.

6. When the carving and painting are completed, it's time to raise the pole. Today a mechanical crane can lift a totem pole into position quickly, but some poles are installed by more traditional methods, with invited guests pulling on ropes to help raise the pole skyward. Once the pole is in place, there are usually speeches, Native dances, and food or gifts for those witnessing the event. These traditional pole-raising ceremonies acknowledge the carvers, the chief or group who commissioned the totem pole, and anyone who assisted in the process.

21

Tools and Timing

Most contemporary totem poles take several months to carve, depending on the size and complexity of the pole, and on the skill and experience of the carving crew. New apprentices require more hands-on instruction than veteran carvers. Fundraising can also take time, since the cost of a new totem pole can run as high as $75,000.

Aboriginal carvers use a mix of modern and traditional tools in their work, ranging from chainsaws to adzes and curved knives.

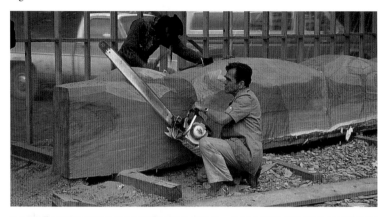

Top: When starting a pole, carvers rely on adzes and chainsaws. Doug Cranmer uses a long blade for rough cuts.

Middle left and right: As the work progresses, they switch to smaller adzes, chisels, mallets and a variety of curved knives.

Left: Many carvers make their own adzes and knives, gradually building up a collection of various blade shapes and sizes. Totem poles are seldom sanded. They get their smooth finish from many, many fine knife or adze cuts.

Training

In earlier times, a young boy who showed an interest in woodworking might be encouraged by a master carver to watch and imitate his work. Copying was the typical method of schooling on the Northwest Coast, as it is in other cultures around the world. The young apprentice would also seek help and guidance from his spirit power. He would learn how to make and handle his own tools, and start carving smaller pieces first. As his skill progressed, he

Randy Adams introduces two Kitwancool students to adzing.

might become advanced enough to work on a totem pole, with the master carver creating the design on one side and the apprentice matching it on the other.

This style of apprenticeship continues today, although carving classes are available in some places. The typical beginner learns from a master carver, often a family member, and works up gradually from small to larger pieces, copying examples to understand the rules and techniques. As they grow in confidence, emerging carvers often try other art forms such as jewellery.

Today Northwest Coast art can be seen in airports and ferry terminals, shopping malls and company boardrooms. Exclusive galleries sell choice pieces to collectors around the world. And an increasing number of people from other cultures understand and appreciate the vitality, skill and dedication involved in Native art. What makes this new interest even more exciting is that aboriginal families and villages are once again commissioning canoes, totem poles, masks and regalia for their own use. A new golden age of Northwest Coast art has dawned, and we are fortunate to be a part of it.

Alaskan master carver Nathan Jackson (right) and Fred Trout take a break from totem pole carving to discuss the merits of a silver bracelet.

Northwest Coast Art

ART WAS CENTRAL TO THE LIFE AND CULTURE of Native people on the Northwest Coast. The figures carved on a halibut fish hook or painted on a steam-bent storage box, for example, were statements about the owner's identity or mythic heritage. In fact, some say that an object was not made right unless it was carved or painted.

Today, totem poles are the best-known examples of Northwest Coast art. But there are many other traditional forms, such as painted canoes and housefronts, carved masks, rattles and ceremonial clothing, as well as spindle whorls, decorated bowls, spoons, tools and other utensils. Native artists have been creating these objects for thousands of years, and new forms of the art have been developed in recent decades. These include silkscreen prints, carved plaques and large free-standing sculptures, all of which are primarily decorative.

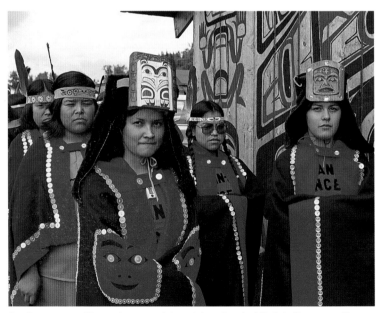

For these young Gitxsan dancers, art is an integral part of their indigenous culture—from totem poles and house designs to the crests sewn on their button blankets or carved on frontlets.

Characteristics

Abstract Creatures

The animal and human figures in Northwest Coast art are abstracts of either natural or supernatural creatures. These stylized beings can usually be identified by one or more characteristic features (see pp 50–61 for a complete listing). For example, beavers are known for gnawing on wood, so Beaver is always portrayed with prominent incisor teeth. Usually the artist includes other characteristics, such as a broad, flat tail or paws holding a chewing stick. But those two big front teeth are always the primary clue. When you spot them, you are looking at Beaver.

Some figures are fairly easy to recognize. Others, especially in highly abstracted artwork, seem confusingly disjointed, with various body parts rotated or placed in unusual positions in order to fit a particular space. These abstract creatures—or parts of them—may also be overlapped or interwoven. A bear may have a frog for a tongue, or a whale may have a human face in its blowhole.

Split Representation

In painted art or shallow relief carving, Northwest Coast artists often depict a figure as though it were split down the middle of its body and opened flat. This allows us to see both sides of the creature, as well as a front-on view of the face.

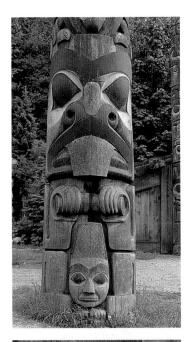

Top right: Beaver is easily recognized by his prominent incisor teeth. This Haida version also has paws holding a chewing stick and a broad, flat tail with a human face tucked up between its legs.

Bottom right: This Killerwhale is more difficult to recognize because its major body parts are placed in unusual positions in order to fit the shape of the pole. Whale's broad mouth is pulled down and the symmetrical tail flukes are tucked up in front until they meet the pectoral fins on each side. An uncharacteristically tiny dorsal fin holds a small figure in its grasp.

Design Elements

Northwest Coast aboriginal artists draw, paint and carve using design elements that have typified the art for centuries. The most common are the **form line** and the use of **ovoids** and **U-forms**. These elements vary slightly from group to group, but they are the basic building blocks of all Northwest Coast art.

A **form line** is the continuous line that delineates a creature's principal shape in flat art. But it is not like the uniform black outline of figures in a child's colouring book. A form line swells and diminishes as it moves, curves and merges to connect all the primary design elements of a figure. It is a key feature of the art—one that holds the design elements together and challenges the viewer's eye to keep moving. A primary form line is usually black and a secondary form line is red.

The **ovoid** is one of the most characteristic of all the Northwest Coast design elements and the most easily identified. It has also been called a "rounded rectangle," an "angular oval" and a "bean-shaped" or "loaf-shaped figure." By any name, an ovoid is a very specific shape, although the proportions may vary. Artists use ovoids for a creature's main body parts—the head, the eyes, the hip or shoulder joint, the base of a hand or foot.

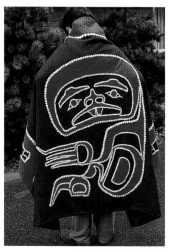

The strong red form line of Norman Tait's Mischievous Man button blanket is powerfully evident. The line swells and diminishes as it moves to unite all the design elements. Note the ovoids used for the head, hip joint, hands and feet.

These ovoid shapes are basic to good Northwest Coast design. Many artists add designs to their ovoids, sometimes producing small creature variations referred to as salmon trout heads.

Variations on hands, feet and claws are easily recognized in Northwest Coast art.

U-forms are design elements shaped like the letter U. When the artist draws a line, deliberately cutting the U-form nearly in two, he creates a split U.

Left: This is a classic Northwest Coast U-form.

Below: This series of split-U's is elegantly carved and painted.

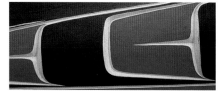

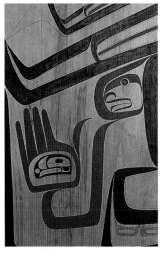

When drawing an eye, the artist adds specific eye forms inside the ovoid. These distinctive eyes and eyebrows are highly characteristic of Northwest Coast art.

Colours

The primary colours of the Northwest Coast palette are black and red, along with green, blue or blue-green. Some groups have also used white and yellow, but these colours were not common in earlier times. Black is used for primary form lines and for eyes or claws. Red is the usual choice for secondary form lines and for lips, nostrils and sometimes bodies.

Before regular trade was established with the Europeans, paint was made from various natural rocks or minerals. Artists ground these into a fine powder and then mixed the pigments with a binding

This hand is built around an ovoid, with a salmon trout head design added in the middle.

agent such as chewed salmon eggs and saliva. Once commercial paints such as the bright "China red in paper packages" became available from the Hudson's Bay Company, carvers readily switched to them.

Early totem poles featured little, if any, painting. As prepared paint became available, this changed, and later totem poles were liberally painted, sometimes in non-traditional colours. Today, some carvers are going back to the earlier tradition, using no paint at all or painting only accented features on a pole. The unpainted Nisga'a totem pole in Stanley Park is an example of the return to a more traditional look.

Regional Styles

All Northwest Coast artists use ovoids, U-forms and form lines as the foundation of their work. However, each group up and down the coast has developed a distinctive, identifiable style. For example, Kwakwaka'wakw poles often feature add-on pieces, so that bird beaks and wings extend dramatically from the body of the pole, as do the rays of the sun or the arms of Dzunukwa, the Wild Woman of the Woods. By contrast, a Haida pole tends to conform to the shape of the original log, with fewer add-on extensions, so bird beaks and wings as well as whale tails and fins are shown folded against the creature's body. The Nuu-chah-nulth use a more rounded style of ovoid, Salish carvers tend toward a more realistic portrayal of animal and human figures, and so on. It takes study and experience to spot the differences, but it's part of what makes Northwest Coast art so fascinating.

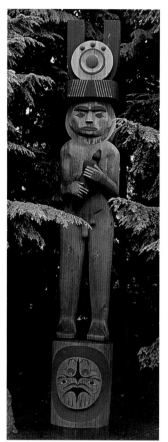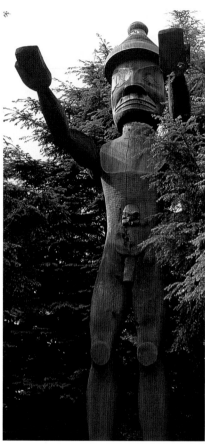

Salish carver Susan Point and Nuu-chah-nulth artist Joe David have both created welcome figures that stand outside UBC's Museum of Anthropology. They provide an interesting opportunity to look at regional differences and similarities in carving styles.

Opposite: This early photograph, taken in 1936, shows the impressive display of Stanley Park totem poles assembled for Vancouver's Golden Jubilee. On the far left was the newly acquired Yakdzi Pole, then the original grouping of two Thunderbird House Posts that flanked the Wakas Pole and the Sisa-Kaulas Pole. On the right were two more newly purchased totems, the Nhe-Is-Bik pole and the Skedans Mortuary Pole. The shed in the background contained two aboriginal canoes. Over the several decades after the picture was taken, all of these poles decayed in the damp climate. They were replaced either by other poles or by replicas. Photo by Dominion Photo Co., Vancouver Public Library VPL23891

Stanley Park Poles at Brockton Point

STANLEY PARK GOT ITS FIRST TOTEM POLE IN **1903**, as a gift. By 1922, members of the Art, Historical and Scientific Association of Vancouver began purchasing poles from northern Kwakwa̱ka'wakw villages, encouraged by W.C. Shelley, chairman of the Park Board. Although somewhat misguided, they were eager to establish a display of aboriginal culture that would further enhance the Park's appeal. More totem poles were added as part of Vancouver's Golden Jubilee celebration in 1936, and again for the Vancouver Centennial and Expo 86.

While the damp coastal climate is perfect for growing massive cedar trees, it is hard on totem poles. Over the years, weather, insects and rot have claimed all of the original poles in the Park. Most of them were taken into museums when they became fragile, and replacements were commissioned and carved. Several new contemporary poles have also been added, and in recent years the Brockton Point site has been landscaped and interpretive signage has been installed.

While the number of totem poles has changed over the years, one thing has remained constant—these massive examples of Northwest Coast Native art continue to fascinate visitors and residents. Each year 3.3 million people visit the totem poles of Stanley Park, making them the number one tourist attraction in the province!

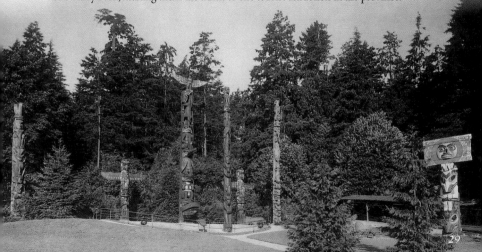

Skedans Mortuary Pole

THIS IS THE ONLY HAIDA POLE and the only mortuary pole in the Park. The original was carved at Skidegate in the Queen Charlotte Islands, probably before 1878. It cost 290 blankets, or $580—a huge sum in those days. A mortuary pole held the remains of a deceased chief in a box that was placed behind the frontal board. The B.C. artist Emily Carr featured the Skedans mortuary pole in one of her paintings.

The Golden Jubilee Committee purchased the pole in 1936 from Henry Moody, who was the current Chief Skedans. It was brought to Vancouver and erected at Lumberman's Arch. By 1962 it had become quite decayed, having been patched with plaster and cement. When the totem poles were taken down because of road construction in the area, this pole fell apart.

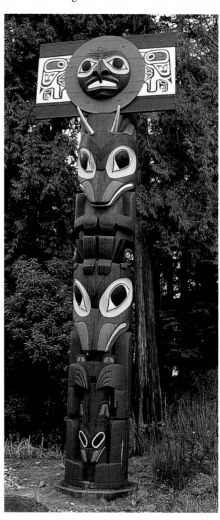

In 1962 Haida carver Bill Reid was hired to carve a replica of the Skedans Mortuary Pole, working with Werner True, a non-Native artist. For some time, fragments of the original were left nearby in the bush. These were eventually sent to the Queen Charlotte Museum. By the 1990s, the face on the front board had again decayed, and Haida carver Don Yeomans was hired to replace it.

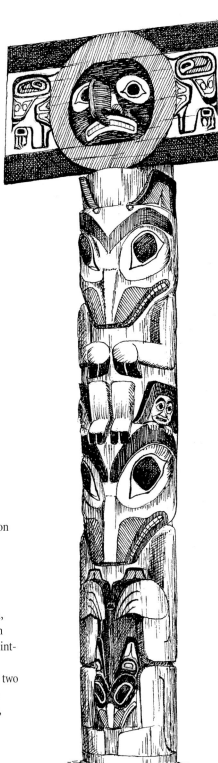

Facts

- Style: Haida
- Height: 8 m (26 ft)
- Replica carved by Bill Reid
- Repaired with a new face by Don Yeomans

Figures

- Frontal board depicts Moon, a chief's crest with a half-human, half-hawk face. The split design shows wings, legs and claws painted on each side,
- Mountain Goat with hoofs and two carved horns, illustrated in the drawing as small round circles,
- Grizzly Bear holding
- a small Whale

Breakfast on the Beach Pole

THE NAME FOR THIS TOTEM POLE RELATES to the first Native name given to carver Beau Dick. Ga'astalas means "breakfast giver" or "a place where you have your first meal." It's a hereditary name that has since been passed on to the artist's firstborn, weaver Kerri Dick.

Beau Dick is a self-taught carver. As a very young man he made drawings of artifacts at the Vancouver Museum. He also watched and learned from other Kwakwaka'wakw carvers and relatives, including Doug Cranmer, Henry and Tony Hunt, his father Ben "Blackie" Dick and his grandfather Jimmie Dick. Beau Dick worked with Wayne Alfred on this totem pole.

The artist explains "the pole was meant to honour our forefathers by keeping the culture alive." He adds that the eastern-style canoe on the totem pole is a tribute to an Ojibway artist who helped with the carving. This totem pole was commissioned by the Kwagulth Urban Society, but the Native group had difficulties securing adequate funding. As a result, the pole took four years to complete. It was finally raised in Stanley Park in 1991 with full ceremonies.

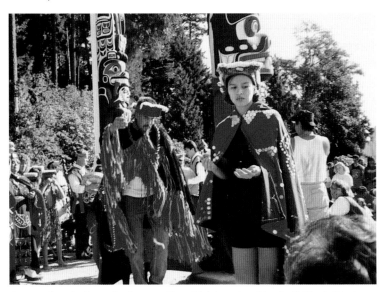

A young female dancer leads carver Beau Dick in pole-raising festivities in Stanley Park. Afterwards, the family hosted a potlatch to honour the Breakfast on the Beach Pole. Photo courtesy of Rita Barnes

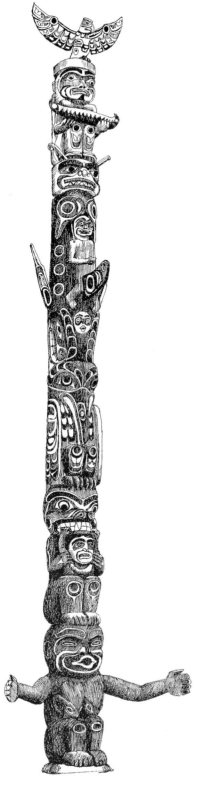

Facts

- Style: Kwakwaka'wakw (also written Kwakiutl or Kwagulth)
- Height: 12 m (40 ft)
- Carved by Beau Dick

Figures

- Eagle (chief's crest)
- Ts'ekame or Red Cedar Bark Man, an ancestor holding a canoe
- Sisiutl
- Siwidi, an ancestor, astride fin
- Supernatural Whale
- Raven
- Grizzly Bear chewing Nulis
- Dzunukwa

Thunderbird House Post

THE THUNDERBIRD HOUSE POST is one of the earliest totem poles bought for Stanley Park. Originally there were two nearly identical interior house posts, which were carved in the early 1900s by Kwakwaka'wakw artist Charlie James (Yakutlas). They were intended for a Kingcome Inlet chief and would have supported one of the crossbeams in his communal house. A second set at the opposite end of the house would have supported a second crossbeam. For whatever reason, it appears that the house was never built.

In 1914 the two house posts were rented as part of a movie set for the Edward S. Curtis film *In the Land of the Head-Hunters*. In 1922, the Art, Historical and Scientific Association bought both interior house posts, the first in a series of totem poles that were intended to be part of an "old-time Indian village" in Stanley Park. This proposed village was never built, but the Park's collection of totem poles continued to grow.

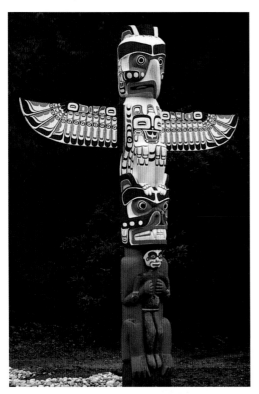

Over the years, one of the two house posts became badly decayed. In 1968, before being taken to the Vancouver Museum for conservation and storage, it was cast in fibreglas and the replica was put up near the miniature railway in Stanley Park. In preparation for Vancouver's Centennial and Expo 86, the remaining original house post was repaired and moved indoors. Kwakwaka'wakw artist Tony Hunt was hired to carve a replica of the left-hand pole, which had gone to the museum in 1968. He worked with John Livingston. Tony's son and Phil Nuytten assisted with painting the replica. They worked from an early photograph in order to accurately paint the pole with Charlie James' original designs. This house post was then put up in Stanley Park.

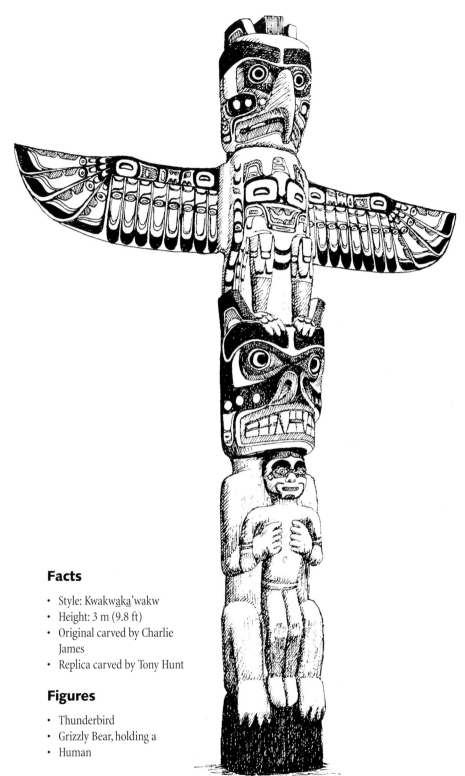

Facts

- Style: Kwakwa̲ka̲'wakw
- Height: 3 m (9.8 ft)
- Original carved by Charlie James
- Replica carved by Tony Hunt

Figures

- Thunderbird
- Grizzly Bear, holding a
- Human

35

Sky Chief Pole

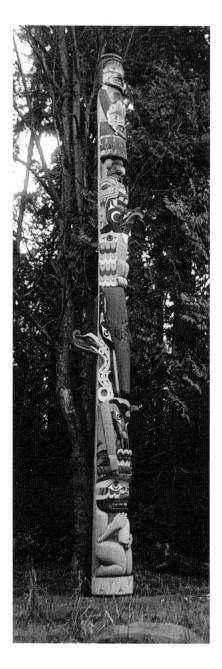

ART THOMPSON AND TIM PAUL carved this pole in 1988, as part of an exchange with the Royal British Columbia Museum for the Yakdzi and Nhe-Is-Bik poles that had been in the Park since 1936 and were badly deteriorated. The Sky Chief is one of four important chiefs in the world. The others are the Mountain Chief, the Sea Chief and the Land Chief.

The two carvers had worked together on other totem poles and projects in Victoria, Vancouver and Neah Bay in Washington state. This time they decided to create a pole that would be a tribute to all Nuu-chah-nulth people, acknowledging the traditions, legends and skills of earlier generations while making their own contemporary statement that the culture is alive and well.

Tim Paul explains that totem poles are extensions of an earlier form of Nuu-chah-nulth art—housefronts with painted cedar boards featuring family crests. "They defined who you were, they told who lived in the house."

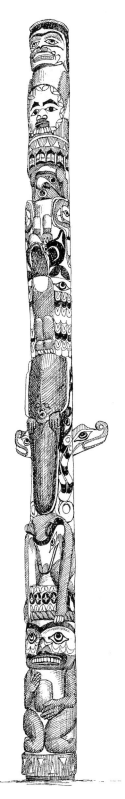

Facts

- Style: Nuu-chah-nulth
- Height: 11.5 m (38 ft)
- Carver: Art Thompson (Ditidaht) and Tim Paul (Hesquiat)

Figures

- Sky Chief holding Moon
- Kingfisher is below Sky Chief's skirt, its clawed feet touch the symmetrical tail flukes of Humpback Whale
- Thunderbird, riding on Whale's back, is being dragged underwater (note its feathered wings at the side)
- Humpback Whale with an unusual blowhole that features both a face and hands
- Lightning Snake, a mythical creature who assists Thunderbird in catching whales, on either side of Whale's snout
- Wolf (the Wolf figure acknowledges Jimmy John, a well-known Nuu-chah-nulth carver of earlier days, and it is carved in his style)
- Man of Knowledge holding *topati*, an object used in certain marriage privileges as part of games or tests of skill and courage

Ellen Neel Pole

ELLEN NEEL CAME FROM A FAMILY of Kwakwa̱ka'wakw carvers and was the grand-daughter of Charlie James. Her Native name was Ka̱kaso'las, which means "people come from far away to seek her advice."

Traditionally, carving was men's work. Ellen Neel was one of the few women to gain renown as a totem pole carver. She was also one of the few to sell her work in Stanley Park. Beginning in 1946, she and her family carved at Ferguson Point. Her Totem Arts studio was actually one of the World War II concrete bunkers that had been built in the Park to guard against possible Japanese invasion.

In 1955, Ellen Neel was commissioned by Woodward's Department Store to carve five totem poles for a mall in Edmonton, Alberta. These poles were all carved in a shed built near their Ferguson Point sales room. Thirty years later, three of those poles were returned to the coast, and this one was gifted to the University of B.C.'s Museum of Anthropology. In 1985 the museum loaned the pole to the Park Board "in memory of Neel's pioneering role in reaching an international audience through her art."

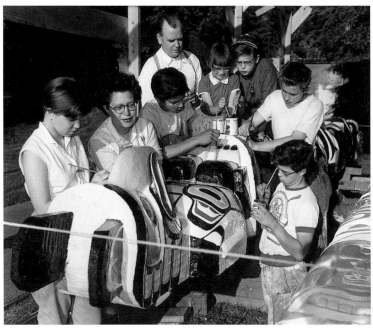

This photograph of the entire Neel family, working on a series of poles for Westmount Mall in Edmonton, Alberta, appeared in the Province *newspaper in 1955. Left to right: Theo, Ellen, Dave, Ted Sr., Bitty, Cora, Bob and Ted Neel.* Photo used by permission of the *Province* newspaper, Vancouver Public Library, Special Collections, VPL 62667

Facts

- Style: Kwakwaka'wakw
- Height: 8.5 m (28 ft)
- Carved by Ellen Neel
- Renovated by son Robert Neel

Figures

- Thunderbird
- Sea Bear holding a Killerwhale; Sea Bear's feet are on shoulders of a
- Man holding a Frog, crouched on the head of
- Bak'was, or "wild man of the woods"
- Dzunukwa, or giantess
- Raven

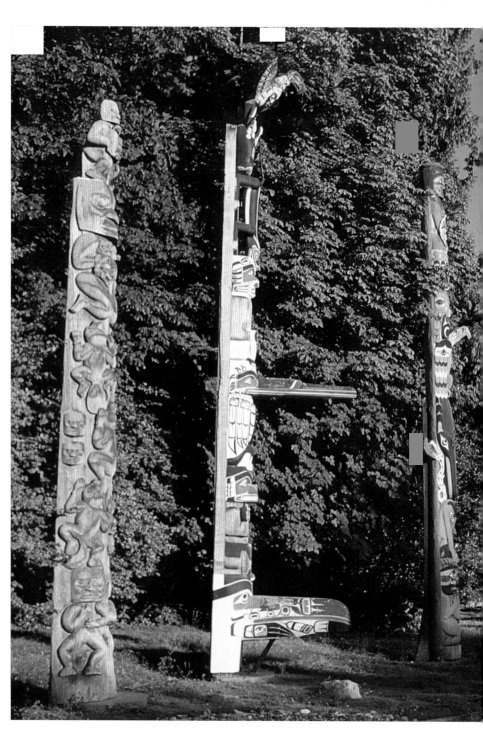

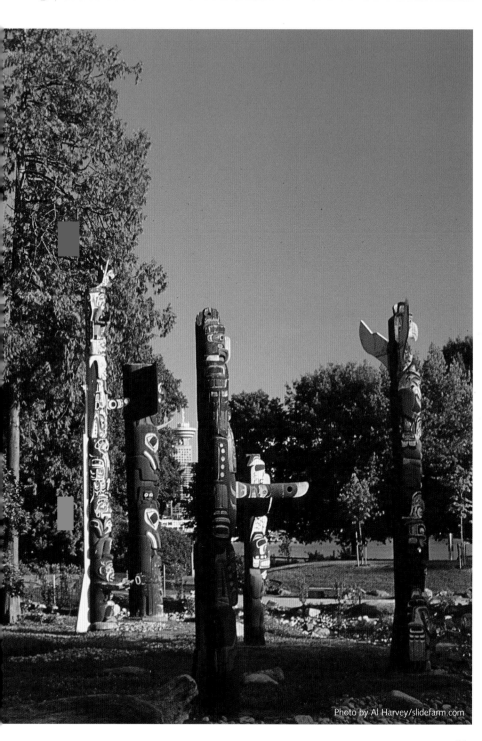

Photo by Al Harvey/slidefarm.com

Wakas (also *Wakius*) *Pole*

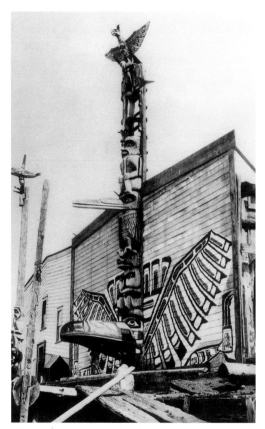

This historic doorway pole, shown here in 1909, stood in Alert Bay until the late 1920s. Raven's wings, tail and legs were painted on the housefront to complete a massive crest figure. An upside-down canoe prow was originally used for Raven's upper beak. Photo by Phillip Timms, Vancouver Public Library, Special Collections, VPL 4909

THE ORIGINAL VERSION OF THIS TOTEM POLE stood at the entrance of Chief Wakas' communal house in Alert Bay. Designed and carved by Yuxwayu, it was raised in the 1890s. Raven's enormous 2.7 m (9 ft) beak was added a few years later. When opened, the beak served as an impressive ceremonial entrance to the communal house. Raven's outstretched wings, tail and feet were also painted on the plank housefront to complete the effect. When the B.C. artist Emily Carr visited Alert Bay in 1903, she made several paintings of this pole.

The Wakas Pole is one of the first totem poles purchased by the Art, Historical and Scientific Association for Stanley Park. They paid $700. After nearly 60 years in the Park, the original pole had deteriorated badly. In the mid-1980s, the Canadian Museum of Civilization agreed to house the pole, in exchange for commissioning a replica.

Doug Cranmer was hired to carve the replica or "new generation" pole, an especially appropriate choice since Chief Wakas was his father's uncle. A young crew helped rough out the pole; then Dickie Sumner and Fah Ambers worked with Doug Cranmer to finish it. The replica was raised with full ceremonial honours in 1987. Bruce Alfred accompanied Doug Cranmer back east, where they completed extensive repairs on the original Wakas pole. It was erected in the Museum's Great Hall exhibit in 1989.

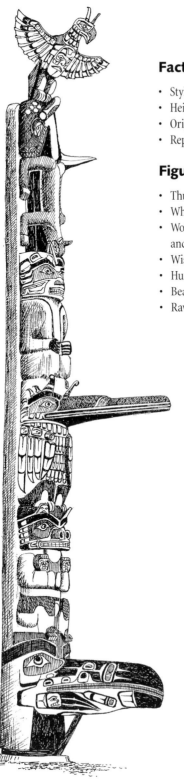

Facts

- Style: Kwakwa̱ka'wakw
- Height: 12 m (40 ft)
- Original carved by Yuxwayu
- Replica carved by Doug Cranmer

Figures

- Thunderbird, whose claws hold
- Whale
- Wolf (head down) (one of the chief's ancestors)
- Wise One, a man of myth
- Huxwhukw, one of the cannibal birds
- Bear with small faces in its paws
- Raven

Beaver Crest Pole

THIS TOTEM POLE IS THE ONLY NISGA'A STYLE POLE in the Park. It is a fairly recent addition, carved in the mid-1980s as part of the Vancouver Centennial and Expo 86 celebrations.

Norman Tait, who had watched tourists take photos of each other in front of the totem poles, deliberately designed this pole so that a person could stand near the hollow at the bottom, link arms with the bottom figures and become part of the pole for the photograph. However, when he realized that the carved arms would be too fragile for this, he modified the pole design.

Norman Tait worked with his son Isaac Tait, brother Robert "Chip" Tait and nephew Ron Telek. They carved the cedar log at Brockton Point, to the delight of thousands of interested visitors. The artist chose not to paint the pole, keeping it in the style of very old totem poles, with minimal or no paint. The figures on this pole represent the legend of how the Tait family came to have Beaver for its crest. The pole was erected in the fall of 1987, with full ceremonies.

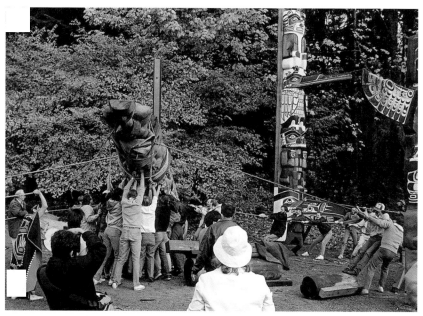

During the summer of 1987, thousands of visitors watched as Norman Tait and crew carved Stanley Park's first Nisga'a-style totem pole. The unpainted Beaver Crest pole was raised in October 1987. Special guests and lucky park visitors were invited to haul on the ropes that lifted the hefty totem into place.

Facts

- Style: Nisga'a
- Height: 9 m (30 ft)
- Carved by Norman Tait

Figures

- Man of the Eagle people (Norman Tait's clan) holding a small Raven
- Large Human figure holding Frog figure in his right hand for Norman Tait's son Isaac, and an Eagle figure in his left hand for Norman Tait's brother Robert, both of whom worked on the pole
- five Beaver figures
- five Human faces representing the five brothers in the myth
- two Beavers who have removed their skins and become Humans at base of pole, one on each side of the smoke hole

Oscar Matilpi Pole

KWAKWAKA'WAKW CARVER OSCAR MATILPI once chuckled over the fact that he'd spent years cutting down trees as a logger and then ended up carving them as an artist!

Originally from Turnour Island, he studied with artist and teacher Henry Hunt while working at the Royal British Columbia Museum in Victoria. Oscar Matilpi carved this pole in 1968 for the Workers Compensation Board building in Richmond, B.C. When the building was remodelled, WCB gifted the pole to Stanley Park.

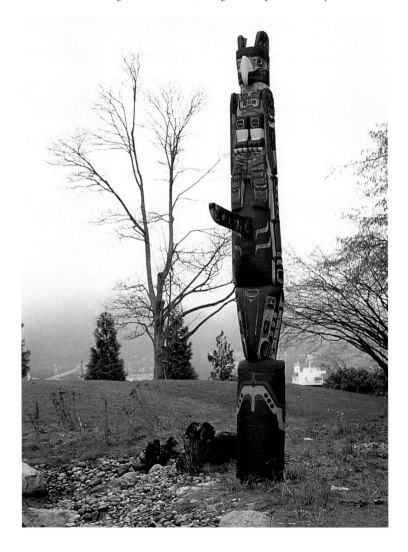

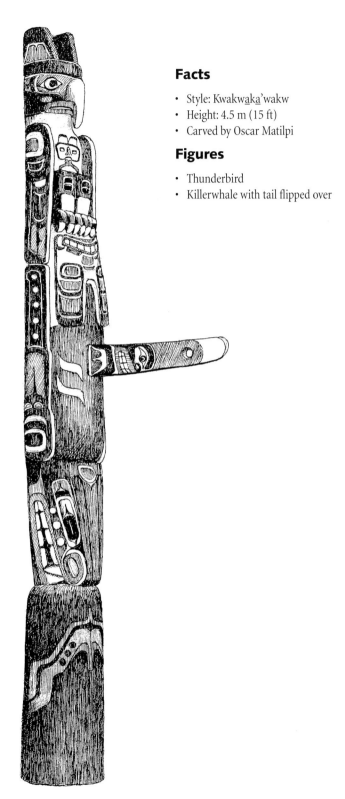

Facts

- Style: Kwakw<u>a</u>k<u>a</u>'wakw
- Height: 4.5 m (15 ft)
- Carved by Oscar Matilpi

Figures

- Thunderbird
- Killerwhale with tail flipped over

Identifying the Figures on Totem Poles

Extraordinary Beings

THE ANIMALS CARVED ON TOTEM POLES are not ordinary creatures of the physical world, but rather supernatural beings that are larger than life. When you see a bear figure with its characteristic fangs, big nostrils, ears, tongue and claws, it's not just any bear, but rather a mythic ancestor or the Bear of legends. To signify this difference, the names of these creatures are capitalized.

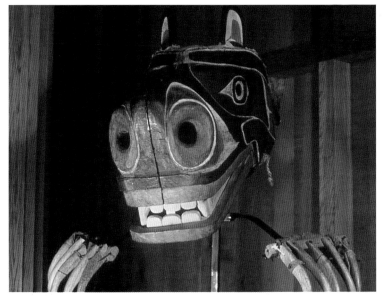

Bear is an important family crest and the subject of many mythic accounts. Bear is commonly featured on totem poles and is usually portrayed holding a human or other smaller creature. The dancer wearing this Bear mask from U'mista Cultural Centre in Alert Bay would also carry the prominent claws.

Many Northwest Coast animals were considered to speak the same language and have the same traits as humans—they lived in large communal houses, they had families and rank, they hosted ceremonies, they had a spirit. Unlike people, animals could change form, appearing and acting sometimes as humans, sometimes as animals. Only in extraordinary circumstances could people be admitted to this animal realm and acquire animal knowledge.

Some creatures of the Northwest Coast may not look like creatures in our visible world—figures such as Double-Finned Sea Bear, One-Horned Mountain Goat, Flying Frog, Split Sea Lion or Lightning Snake. Similarly, some human-like beings, such as Fog Woman, Split Person or Running Backwards, don't fit the prevailing image of people. Learning to identify these unique creatures usually involves understanding the mythic stories of the indigenous culture.

Mary Johnson of Kispiox displays the one-horned Mountain Goat crest on her button blanket regalia.

Transformation Figures

A transformation figure is a creature caught in the process of moving between the human and animal worlds. To show this dual nature, the artist often combines animal and human body parts on the same figure. Human arms may have feathers, or a human face may have a hawk-like beak, as on the Haida mortuary pole in Stanley Park. Some transformation figures remain quite mysterious and hard to identify.

The transformation figure on this Kitwancool totem pole has both human arms and feathers.

Tricksters

All Native cultures have trickster figures that are wise, mischievous and even foolish. On the Northwest Coast there are many different versions of trickster stories. Among northern groups, Raven is the most familiar trickster figure. Sometimes he has a special local name; for example, the Gitxsan call him Weget. On the southern and central coast, the role of trickster and innovator falls to Mink and Blue Jay. Trickster tales belong to everyone and are told and retold for entertainment and instruction.

Other Supernatural Creatures

As well as tricksters, there are other types of supernatural creatures with special powers. For example, Thunderbird can cause a large clap of thunder simply by flapping its wings. Sisiutl is a powerful two-headed sea serpent that looks both forward and backward in its search for truth. It can change its form or turn unbelievers to stone. Other figures are considered to be spiritual because they inhabit two worlds. For example, otters and frogs live on land and in the water.

Identifying Creatures

To learn to identify the major figures on totem poles is the first step in understanding the poles. Each artist carves various natural or supernatural creatures using one or more symbolic anatomical features, such as ears, beaks, teeth, tails, limbs and fins. Once we can recognize these features, we can usually figure out what creature is on the totem pole.

Knowledge of common Northwest Coast stories also can help us identify combinations of creatures. For example, Thunderbird is often shown with his claws in a whale, and Raven may hold a circular object in his beak, based on the myth of Raven stealing the sun. Some carvers use figures that are specific to their area; for instance, the Haida often crown their totem poles with Watchman figures.

Some of the most common crest figures carved on totem poles are:

Birds

All bird bodies are shown with beak, wings, feathers and claws. Most birds have eyebrows and ears atop their heads, but it's the style of beak that is the most helpful clue in differentiating them.

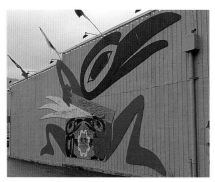

Until it was painted over, the wall of one business in Juneau sported this mural of Raven bringing light into the world. Often artists portray Raven with a circle in his beak, symbolic of the sun released from a steam-bent box.

Raven: Raven is an extremely important cultural hero, as well as a mischievous trickster and transformer. One of the best-known stories tells how Raven brought light into the world by releasing the sun and moon from a bentwood box and tossing them into the sky. Although he possesses supernatural and magical powers, Raven is not the Creator. Raven is a paradox, capable of both helpful and harmful deeds.

Look for:

- a straight, strong or heavy beak, sometimes bent down to accommodate the shape of a pole
- a ball or disc in the beak, depicting the sun or moon

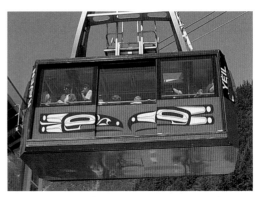

In Juneau, Alaska, the Mt. Roberts tramway car features Raven and Eagle, two major crest figures of the area. Beak shape is the key to telling which is which—Eagle's curved beak contrasts with Raven's straight one.

Eagle: There are many myths and legends about Eagle on the Northwest Coast. The soft down from Eagle's underbelly is a symbol of peace and friendship; Eagle's feathers are used in rituals and decorate some masks and headdresses. As one of the main northern crests, Eagle is portrayed in many art forms.

Look for:

- a strong beak, shorter than Raven's
- a beak that curves or hooks downward at the tip (other birds also have a downward curved beak, but Hawk's and Thunderbird's beaks recurve inward)
- no curled appendages extending from the top of the head (if these "horns" are present, the figure is more likely Thunderbird)

The curved beak on this baby Eagle bowl by Isaac Tait is the clue to its identity. The wide-open mouth is also typical of all baby birds

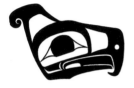

Thunderbird: This mythological bird, sometimes called Lord of the Upper World, is considered to be one of the most powerful of all the spirits. When Thunderbird flaps his wings, the thunder rolls; when he blinks his eyes, lightning flashes. Others say this mythic bird has lightning sticks under his wings. Thunderbird is powerful enough to snatch whales from the ocean with his great talons and fly off with them.

Look for:

- a curved-down beak, much like that of Eagle
- curled appendages on the head, sometimes referred to as "horns" and considered symbols of the bird's considerable power
- great outstretched wings

Kolus (also **Quolus**): This giant bird, a relative of Thunderbird, is so powerful that he can lift house beams and put them into position.

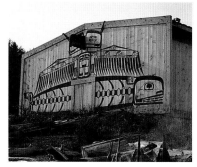

Thunderbird is often shown with his claws in the body of Whale, as shown here on the painted front of U'mista Cultural Centre in Alert Bay.

Look for:

- a curved-down beak
- feathered appendages ("horns") on the head, but straight and horizontal, rather than curled as on Thunderbird

Hawk: This bird looks like Thunderbird but his beak is even more strongly recurved, often reaching back to the lower jaw.

Look for:

- a strongly recurved beak, often reconnecting with the lower jaw
- no feathered appendages ("horns") on the head, although ears may be present

Cannibal birds: These flesh-eating bird-monsters are servants to the powerful Man Eater at the North End of the World. **Huxwhukw** (also **Hokw Hokw**) has an enormous long, straight beak, which he uses to crack open the skulls of men in order to eat their brains. This bird is a crest of the Kwakwaka'wakw (Kwakiutl) and Nuxalk.

Look for:

- an enormously long, powerful, straight beak

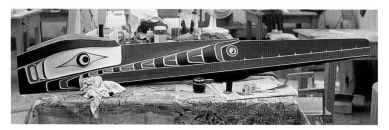

This newly carved Huxwhukw mask features its characteristic long beak. Once the paint dries, the artist will attach cedar bark fringe.

Owl: This distinctive bird, thought by many to be a shaman's helper, was often considered to be a messenger of death or bad fortune.

Look for:

- large, round eyes
- a sharp, short beak

Other birds: Northwest Coast artists portray a variety of other birds. Usually the beak shape is the primary clue to distinguish one from another. For example, **Oystercatcher** has a long, narrow beak and long, skinny legs. **Hummingbird**'s beak is long, narrow and curved.

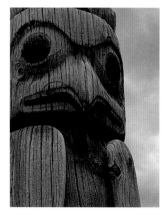

This Gitxsan totem pole displays an easily recognized owl crest.

Fish and Sea Mammals

All fish have a natural fish-shaped body with appropriate fins and tail. The artist adds the specific details for the type of fish he is drawing or carving.

Salmon were a vital food source for both humans and animals on the Pacific coast, so it is understandable that salmon represented wealth. Artists recognized and portrayed the five different species, sometimes likening them to five different clans, each with separate villages in the sea.

Look for:

- natural fish-shaped body with fins and tail
- presence of many circular eggs, often shown to represent spawning female salmon

Halibut is identified by his distinctive flat shape, and a head with the mouth to one side and eyes off centre.

Look for:

- flattened body
- both eyes on the same side of the face

Right above: Salmon are easy to recognize, although artists may specifically depict any of five species. Females are shown with many small, circular eggs

Right: This large, unfinished bowl has the distinctive flat body and face of a mature halibut, with both eyes on the same side.

Whales are among the most commonly portrayed creatures in Northwest Coast art. Their body parts can easily be lengthened or shortened to fit on a totem pole or other artwork. Various species of whales were shown; sometimes the different types were likened to human clans.

Look for:

- a rounded snout
- a large mouth
- a dominant dorsal fin on its back
- pectoral (side) fins
- a blowhole (sometimes shown with a face peering out)
- symmetrical tail flukes, which may be stretched out long and flat or curved over the animal's back

Wayne Hewson's Tsimshian-style regalia features a double-finned Killerwhale with distinctive blow hole, large mouth, rounded snout and tail flukes.

Killerwhale (orca) has a long, prominent dorsal fin on its back, a blowhole, short pectoral fins and generally a mouth full of teeth. One of the crests depicted most often, Killerwhale is considered to be Lord of the Undersea World and the greatest hunter in the sea. Because these animals hunted in packs like wolves, the creature was sometimes called Sea Wolf, or Wasgo.

Humpback (or **Grey**) **Whale** is shown with long, slender pectoral fins and a minimal dorsal fin. Spots are often painted on his back, perhaps indicative of the barnacles that live on humpback whales.

Shark or **Dogfish** is a fierce, menacing figure, often seen on Haida totem poles.

Look for:

- a high, domed forehead with wrinkles
- a series of gill slits
- a large down-turned mouth, generally filled with sharp, triangular teeth
- eyes with vertical pupils
- sharp spines
- asymmetrical tail flukes

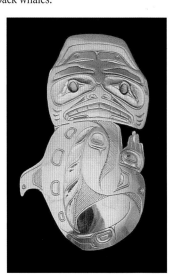

The artist who created this gold shark accented the creature's high, domed forehead, large downturned mouth and gill slits on either side of the mouth.

Land Mammals

Bear (generally black bear but sometimes grizzly) is the subject of many legends on this coast and one of the most common figures on totem poles. Known by some groups as "Elder Kinsmen," bears and humans had similar social communities and practices. Bears could transform themselves to appear as human beings and occasionally abducted or married human women, who then bore Bear children.

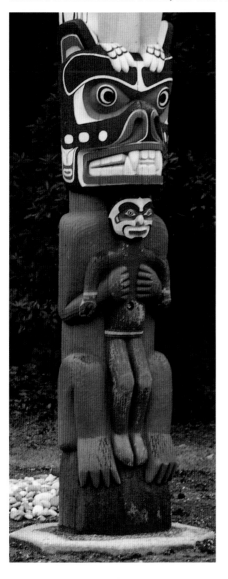

Look for:

- prominent ears, sometimes with smaller creatures peeking out
- a snout with round or flared nostrils
- often a large mouth, sometimes filled with teeth, including pointed canines
- sometimes a large protruding tongue
- often upright human-like seated position
- paws with large claws
- no tail, or a very stubby one

Sea Bear is a crest variation that has the characteristics of Bear as well as one or two whale fins on his back. Sometimes the creature is identified by the number of fins on his back (for example, a Two-finned Sea Bear).

The Thunderbird House Post in Stanley Park shows Bear with prominent ears, large flared nostrils and a sizable mouth filled with teeth. Bear is often clasping a human or animal in its claws, in this case Man.

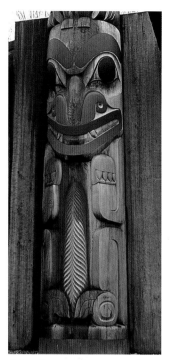

This pole carved by Jim Hart features a large Wolf. The main clue to help with identifying this creature is its prominent tail. Bears are seldom shown with a tail, or only a very stubby one.

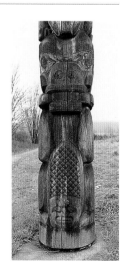

Wolf is considered to be an extremely good hunter, with a keen sense of smell, sharp eyesight, powerful legs and superior knowledge. Some groups feel that Wolf is the land equivalent of Killerwhale.

Look for:

- a long, narrow snout (longer than Bear's)
- a mouth with sharp teeth, sometimes including canines
- a protruding tongue
- a prominent tail, bushy and curled or straight and black-tipped
- pointed ears

It can be hard to distinguish Wolf from Bear. Remember that Wolf has a long, narrow snout and a prominent tail, while Bear generally has no tail at all. Wolves with fins or flippers represent the mythical Sea Wolf, or Wasgo.

Water Animals

Water animals include frogs, otters, seals and similar creatures, most of which are quite identifiable by their body shape.

Beaver is one of the easiest creatures to identify, with his two prominent incisor teeth.

Look for:

- two large incisor teeth
- a prominent flat, cross-hatched tail, usually shown flipped up in front, between the animal's hind legs, sometimes with a small face at the join of tail and body
- front paws grasping a chewing stick or arrow
- ears and rounded nostrils

The Beaver on this totem pole shows most of the typical identifiers—two large incisor teeth, a chewing stick in its hands, and a prominent tail with cross-hatching and a small face where the tail and body join.

Frog is another mythic creature that is easily identified by its unique anatomical features. The Gitxsan have a winged or flying frog as a prominent crest.

Look for:

- a wide, toothless mouth, often with thick lips
- large, rounded eyes
- feet with toes
- (often) legs crouched, as if ready to hop away
- no ears, teeth or tail
- green (if painted)

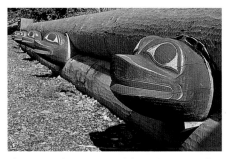

This series of Frogs at Ketchikan's Saxman Park is easily identified because of the green paint and wide, toothless mouths.

Other Figures

Sisiutl (also **Sisioohl**, **Sisiyutl**) is a mythical two-headed sea serpent. This creature is a soul searcher and can see from both front and back. Continually searching for truth, Sisiutl has the power to bring both good and evil. Those who survived an encounter with the serpent often were given great personal power. Sisiutl had the ability to change forms, in some stories becoming an invincible canoe.

Look for:

- a long, cylindrical body with a human head at the centre and a serpent's head in profile at each end
- teeth
- a large curled tongue at each end of the body
- (sometimes) fins or scales running along the body
- horns or curled appendages on the head

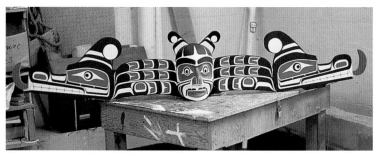

This Sisiutl mask is easy to identify. It features the long body with a human head at the centre and a serpent's head in profile at each end.

Lightning snake is another powerful serpent creature that often assists Thunderbird in catching whales. This creature has a serpent-like body and the head of a wolf.

Heavenly bodies such as the **Sun** and **Moon** do not figure strongly in Northwest Coast myths, except for the popular story of Raven releasing them into the sky from a steam-bent box.

Sun is easily recognized by its round shape and extending rays. Sun's face is often depicted as Human, with a Hawk-like beak.

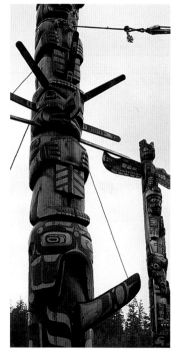

Look for:

- a circular shape
- rays extending out from a full face
- a Hawk-like beak

Moon is shown either as a full circle or as a crescent.

Look for:

- a circular face or crescent shape
- (usually) a smooth, round rim, rather than rays extending outward
- a full or profiled face

Coppers are highly prized symbols of wealth that indicate the high rank and/or prestige of their owners. They were made from raw or native copper, which was beaten into the distinctive shape. Usually a Copper was painted with a face and ribs and was given a name that related to its value, such as Making-the-House-Empty-of-Blankets or All-Other-Coppers-Are-Ashamed-to-Look-at-It.

Look for:

- the distinctive Copper shape, often held by a chiefly figure

Above: The Sun on this Kwakwa̱ka'wakw memorial pole has a Hawk-like beak on its face and rays that extend outward from the centre. Sun is shown holding a Copper.

Right: This display of Coppers is at U'mista Cultural Centre in Alert Bay. Some Coppers are whole; others have been deliberately cut or "broken" at a potlatch, showing that the owner is so wealthy he could disregard its value.

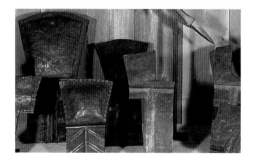

Steam-bent boxes (also **bent-wood boxes**) were used to store prized possessions or food supplies. They were made by notching, steaming and bending a single plank of cedar into an open box shape with four sides. The open seam was then dowelled, sewn or tied shut with cedar twine and the bottom piece fitted on. Some groups used these boxes for burials, including them as part of a mortuary pole.

Look for:

• a box-like shape

UBC's Museum of Anthropology has an impressive display of steam-bent storage boxes. Most were decorated, with the form lines still visible.

People

Humans are usually given a semi-realistic portrayal and often shown in a crouched position. A male chief may wear a cedar bark neck ring or a woven potlatch hat. Some Native male figures have moustaches. A non-Native male may be shown with a stovepipe hat or with a full beard. A female typically has breasts and wears a skirt. She usually has a lip plug, or labret. This ornament is worn in a perforation in the lower lip and shows noble birth or rank.

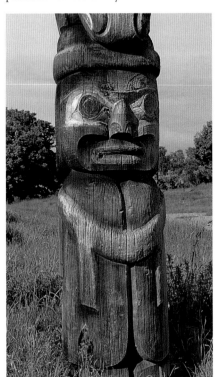

Look for:

• human facial and body features
• a neck ring or potlatch hat
• hair
• a labret, often shown as an oval in the lower lip of a woman

The carver has added a neck ring to this Man.

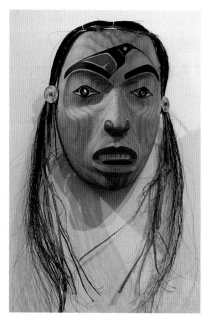 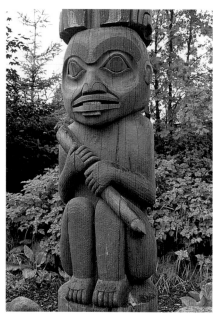

Left: Doreen Jensen's female mask is easily identified because of the labret in her lower lip.

Right: Woman is easily distinguished because she often is shown with a labret in her lower lip. Here she also carries a stick for digging root vegetables.

Below: Crew members finish up the three Watchman figures that crown this Jim Hart totem pole, part of the Haida village display behind UBC's Museum of Anthropology.

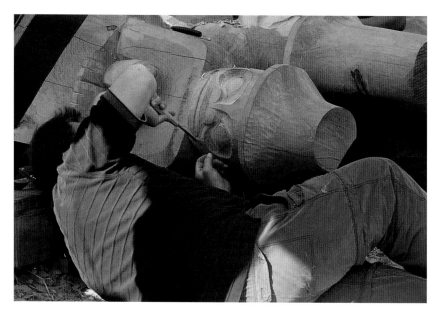

Watchman figures: This cluster of small human figures typically crowns a Haida totem pole. Usually there are three of them, each wearing a hat with rings, or skils. Every skil was said to represent a potlatch the chief had hosted. Watchmen had supernatural powers and were said to keep a protective lookout over a household or village.

Her deep-set eyes, rounded, pursed lips and black colour make Dzunukwa easy to recognize.

Look for:

- a cluster of small human figures, usually three
- ringed hats on the figures' heads

Dzunukwa (also **Dzonoqua, Tsonoqua**) is a fearsome female giant also known as Wild Woman of the Woods, or Property Woman. Her house was filled with various treasures and supernatural powers that humans might acquire if they survived an encounter with her. The giantess was considered to be slow and stupid, but she had a reputation for seizing crying or disobedient children, stuffing them into her pack basket and later devouring them.

Look for:

- a definite female form, often with pendulous breasts
- rounded, pursed lips
- deep-set eyes, often half-closed
- a black body and face

Bak'was (also **Bukwus**), is the Wild Man of the Woods. Among northerly groups, Bak'was is a shy Sasquatch, an ape-like primate.

Look for:

- a male figure with pursed lips
- (sometimes) a strongly recurved nose

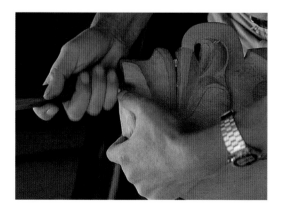

Doug Cranmer's Bak'was mask shows a strongly recurved nose.

Stanley Park: Then and Now

The First People

IN THE SUMMER OF 1792, the British sea captain George Vancouver and a small exploration party ventured into Burrard Inlet. The Spanish captains Galiano and Valdes of Spain had explored the inlet earlier that summer and were the first Europeans to glimpse the heavily forested peninsula that would become Stanley Park.

During their brief visits to the area, both British and Spanish explorers were greeted by canoeloads of Natives. These were friendly encounters, as noted in Captain Vancouver's journal:

> Here we were met by about fifty Indians, in their canoes, who conducted themselves with great decorum and civility, presenting us with several fish cooked... These good people finding we were inclined to make some return for their hospitality, showed much understanding in preferring iron to copper.

Long before these Europeans' arrival, Coast Salish peoples maintained village sites throughout Burrard Inlet while they fished, hunted and foraged. In fact, based on the great depth of the middens (clamshell refuse deposits) in Stanley Park, archaeologists estimate that indigenous people gathered seasonal foods in the area for thousands of years.

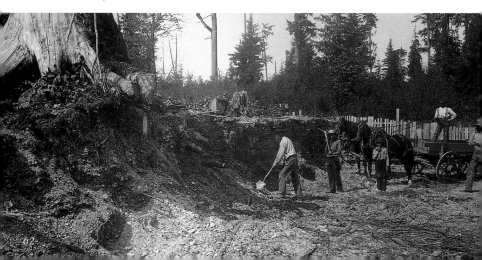

Ancestors of the Musqueam, Squamish and Tsleil-waututh were associated with the area now known as Stanley Park. The Squamish people maintained a village that was situated near today's Lumberman's Arch. They called it X̱wáy'x̱way (pronounced "Whoi-whoi" in English), meaning "mask place." Another, smaller Squamish village was located west of X̱wáy'x̱way, on what is now an open, grassy area where the City of Vancouver water pipeline crosses. It was known as Schílhus (written as Chaythoos in many accounts), meaning "high bluff." Both of these villages were identified as Squamish settlements on a map drawn in 1863.

Native and Non-Native Residents

By the late 1850s, Portuguese ship jumpers and other non-Native pioneers were living in the Stanley Park area as well. Many of them married Native women and built houses near Brockton Point. In 1865 these homesteads and the nearby village at X̱wáy'x̱way were threatened by plans to build a sawmill. Loggers went to work clearing forested areas, hauling logs out on rough skid roads that became many of today's park trails and roads. Eventually the mill was located elsewhere, but the cleared land encouraged more people to settle on the peninsula.

A census conducted in 1876 enumerated about 50 Squamish Indian people living in the villages at X̱wáy'x̱way and Schílhus. Some resided in big community houses; others occupied smaller dwellings. These people were encouraged to settle elsewhere in Burrard Inlet, but a number of them simply stayed put. Little is known about the early history of these two villages, but Squamish elders interviewed in the 1890s recalled earlier times when thousands of Natives journeyed to X̱wáy'x̱way for potlatches.

The City and the Park

In 1886, the Townsite of Granville incorporated as the City of Vancouver. The first order of business of the new Vancouver City Council was to establish a park on much of the nearby forested peninsula. The Dominion Government agreed to City

Opposite: "Midden" is the archaeological term for a garbage heap that contains valuable clues to tools, foods and other facets of a culture. The great depth of the clam-shell refuse in Stanley Park middens—nearly 2.5 meters (8 feet) in some places—indicates that Native peoples gathered seasonal foods in the area for thousands of years. Today these sites are protected by law, but near the end of the 1800s, shell deposits from the large Lumberman's Arch midden were routinely used in surfacing new Park roads. Working with picks and shovels to excavate tons of shells, workers came across a number of human skeletons. The larger bones and skulls were gathered up and placed in boxes, which were later tucked away in the forest. Some skeletons were sent away to museums. In the mid-1950s, Don Abbott, an archaeologist, conducted limited surveys of various Stanley Park sites, but to date there has been no systematic archaeological excavation.
Charles S. Bailey photo, City of Vancouver Archives S9N 91

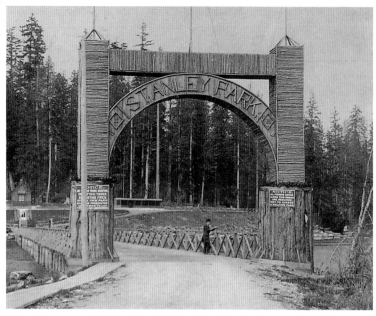

Before Vancouver City Council voted to build a bridge linking Stanley Park to Georgia Street, visitors could only get there by crossing over a large log anchored in the muddy tidal flats. This photo shows the entry arch and early wooden span bridge that provided easier access to the park. This bridge was replaced in 1905 with a solid embankment, or causeway, which provided the entrance still in use today. Lost Lagoon was created in the process. Bailey Bros. Photo, City of Vancouver Archives, Arch P52

Council's request and leased the Burrard Peninsula for park purposes at the rate of $1 per year, an arrangement that is still in effect today.

Stanley Park was opened on September 27, 1888. One year later, Canada's Governor General, Lord Frederick Arthur Stanley, officially dedicated the park "to the use and enjoyment of all colours, creeds and customs for all times." This is the same Lord Stanley who donated a silver trophy to be awarded to Canada's top-ranking amateur hockey club. The famous Stanley Cup was later adopted as the championship prize in professional hockey.

The Scourge of Smallpox

A series of smallpox epidemics, beginning in the 1770s–80s, devastated Native populations throughout the Northwest Coast. The village of X̱wáy'x̱way in Stanley Park was no exception. Natives who died there were buried in various locations in the park. A few were placed above ground in canoes. Still others were put in burial boxes that were then hoisted up into trees.

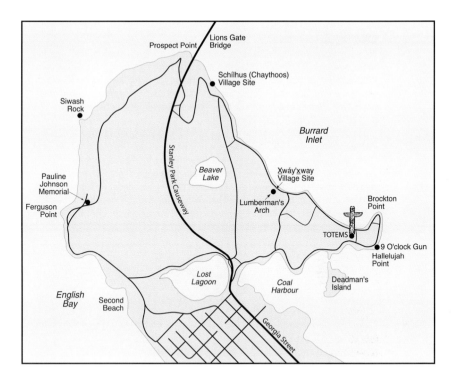

The smallpox epidemic of 1888 had a particular impact on the residents of Stanley Park. The city enforced quarantine restrictions and set up a temporary isolation hospital at nearby Deadman's Island. Most of the Natives had left the village site at Lumberman's Arch, so the new City Council decided to destroy the houses at X̱wáy'x̱way "on account of smallpox." Authorities resettled the remaining people and burned the village to the ground. All that remained were a few boxes in trees.

By the early 1900s, automobiles were a common feature in the park, and it became a popular pastime to drive under the Lumberman's Arch structure. The original wooden arch became unsafe and was replaced in 1952 by the huge angled cedar log that is a familiar landmark today. "Lumberman's Arch" also refers to the area of Stanley Park that encompasses the Variety Kids Water Park, concessions, and the large grassy area that is a favourite picnic ground in summer months.

The Squatters

From the time the Burrard Peninsula was declared park land in 1886, local governments had worked to evict all residents. In the early 1920s, city, federal and Park Board officials joined forces in the Squatters' Eviction Trials. This court action was a bitter experience for Native and non-Native families alike; some had lived in Stanley Park for three generations.

DEADMAN'S ISLAND

For many years, Deadman's Island served as a graveyard. Native corpses were often put into bentwood boxes and then placed in the branches of high trees. A number of these lofty burial boxes were still visible in the late 1880s. The island was also used for some non-Native gravesites, as were other parts of Stanley Park. During an outbreak of small-pox in 1888, the fledgling city of Vancouver enforced quarantines and set up an isolation hospital on Deadman's Island.

By 1929 Deadman's Island had been completely logged, and all squatters living there had been evicted. In 1942 the island was transferred to the Department of National Defence for use as a Royal Canadian Naval Volunteer Reserve base. A permanent cause-way was built, and a naval cadets training school was opened in 1944. Today the sur-rounding waters of Coal Harbour are home to floating fuel docks and an interesting assortment of boats. Deadman's Island has changed dramatically since the 1800s when it was densely forested, Coal Harbour teemed with herring, and the clam-rich beaches were visited regularly by Coast Salish peoples.

This 1898 photograph of Deadman's Island shows the bridge built to give access to the smallpox isolation hospital. Squatters' shacks are also visible along the shore. Vancouver historian and archivist Major J. S. Matthews crossed the bridge a decade after the epidemic and noted "a few neglected graves, picket fences around them, were hidden, desolate, in the dark, damp silence beneath the trees." City of Vancouver Archives, St Pk P42

Only one so-called "squatter" waged a successful legal campaign. A Native Squamish woman commonly known as "Aunt Sally," whose ancestral name was Syex̱waliya, was able to prove that she had occupied a property in the park for 60 years. According to law, that gave her title to the site. Unfortunately, Aunt Sally died

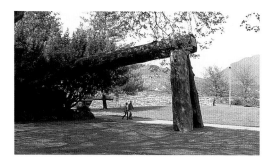

The original Lumberman's Arch became unsafe and was replaced in 1952 by the huge angled cedar log that is a familiar landmark today.

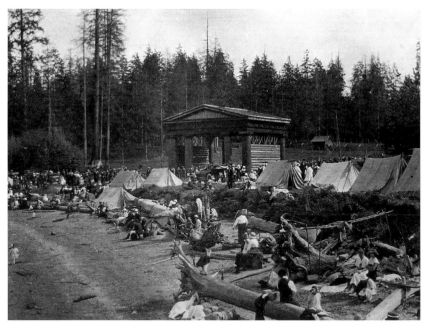

Lumberman's Arch was one of several arches built for the visit in 1912 of the Duke of Connaught. The structure was then presented to the Park Board, which had it re-erected a year later near the site of X̱wáy'x̱way, a Native village. This photo, taken circa 1913, shows a number of Natives camped on the shore by the former village site. City of Vancuver Archives, Arch P40

before the case was formally resolved in her favour. In 1925, Park Board Commissioner W.C. Shelley purchased Aunt Sally's land from her daughter Maria for $15,000, and turned it over to the Board.

The few remaining "squatters" were allowed to stay on in the park until 1931, as long as they paid a rent of $1/month. One blind man, Tim Cummings, of mixed Native ancestry, was given permission to continue living in Stanley Park for the rest of his years. He died there in 1958 at the age of 77.

No monument marks the generations of Native and non-Native people who lived in Stanley Park. The lilac bushes near the Nine O'clock Gun and Hallelujah Point are the only visible reminders of the "squatters" who lived there.

Totem Poles for a Model Indian Village

Ironically, during the decades that officials worked to evict Natives from the park, there was growing interest in some display of "Indian arts and crafts." The assumption was that locals and tourists alike would come to see vestiges of a disappearing culture. Totem poles were chosen as the perfect drawing card, even though local groups did not carve them.

The first totem pole, one from the Skeena River, was donated to Stanley Park in 1903. Totem pole collecting began in earnest in 1919 when a local civic organization, the Arts, Historical and Scientific Society, presented a bold plan to the Park Board. They proposed a "model Indian village" that would "suitably house and preserve historical relics and curios relating to the Indians." The idea was to purchase "some old, deserted village," transplant it to the proposed site, and reassemble it there. The Board gave vigorous assent to the proposal.

Charlie James carved many of the early Park poles as well as influencing other carvers with his strongly expressive style. He was Mungo Martin's stepfather and Ellen Neel's grandfather. B.C. Archives, PN 2315

The Arts, Historical and Scientific Society purchased two interior house posts carved by well-known Kwakwa̱ka'wakw artist Charlie James. Park Board chairman W.C. Shelley then bought a third Charlie James pole and challenged the Society to match his gift. They did so in 1922. These four totem poles were erected at Lumberman's Arch.

The Coast Salish peoples in the Burrard Inlet area did not traditionally carve totem poles. Similarly, the plans for the proposed "Indian village" were not in the style of Salish housing but represented Kwakwa̱ka'wakw architecture. The commonly held bias was that northern-style art and culture was somehow superior to that of southern groups. This prejudice was evident in a 1925 *Province* newspaper story proclaiming that the Kwakiutl and Haida were "the most advanced of all British Columbia tribes in culture," and in a Stanley Park guidebook of the day, stating that the Kwakiutl Indians and the Haidas were "the most outstanding and intelligent of the tribes."

The Squamish Indian Council publicly stated its opposition to the Stanley Park plan late in 1925, noting that neither the planned village nor the totem poles were indigenous to the area and that the proposed site was formerly a Squamish village. Concerned about the growing controversy, the Arts, Historical and Scientific Society turned responsibility for the project over to the Park Board. Chairman Shelley was reluctant to give up on the idea of an "old-time Indian village," but the project was eventually abandoned.

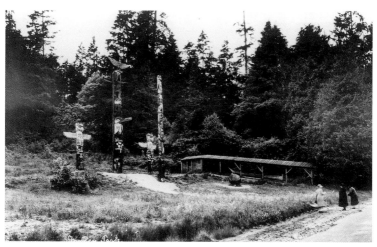

The first totem poles erected in the Park attracted the attention of tourists and locals alike. Note that when this photo was taken, the Wakas Pole did not have its massive beak attached. Leonard Frank photo, Vancouver Public Library VPL 4600

Vancouver's Golden Jubilee

Despite the ongoing impact of the Depression, Vancouverites were determined to celebrate the city's Golden Jubilee in 1936. Official sanction was given for a temporary "Indian building" that would be constructed as part of the Jubilee celebration. Tl'ísela (also known as Chief Mathias Joe) was a major attraction, selling model totems and telling "Indian stories."

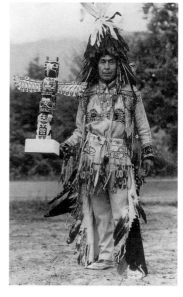

The Vancouver Golden Jubilee Committee, along with the Indian Department, acquired a number of old totem poles for the Park, including the Haida mortuary pole and two more Kwakwa̱ka'wakw poles: the Nhe-Is-Bik Salmon Pole and the Yakdzi Pole (sometimes written Yardzi). The Park's existing totem poles were refurbished as well, and paved walkways and railings were added to the site.

Tl'ísela (Mathias Joe) was a major feature of the Stanley Park "Indian Village." He sold model totem poles such as the one shown here and related "Indian stories." Vancouver Public Library, Special Collections, VPL 11644

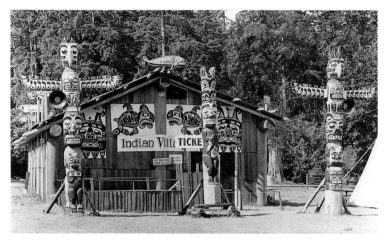

Admission to the Golden Jubilee "Indian Village" cost 10 cents. A Plains-style teepee was erected next to the building. There's little mention of who carved these totem poles or what happened to them afterwards. Vancouver Public Library, Special Collections, VPL 4941

Although the Squamish did not traditionally create free-standing totem poles, Chief Mathias Joe carved a pole to commemorate the historic meeting of the Squamish with Capt. George Vancouver in 1792. It was erected at Prospect Point in time for the Jubilee.

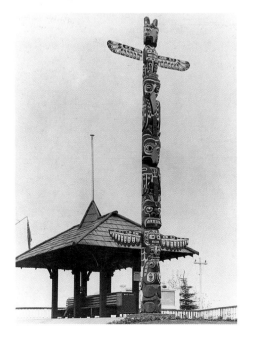

The Thunderbird Dynasty Totem at Prospect Point was a popular tourist stopping point until the pole eventually succumbed to an infestation of carpenter ants. The four winged crests on the pole represented the Thunderbird family; the giant sea monster at the bottom of the pole was the main food for these supernatural birds. Vancouver Public Library, Special Collections, VPL 4931

A Native Workshop in the Park

In the mid-1940s, the Kwakwa̱ka̱'wakw carver K̲akaso'las (Ellen Neel) and her family began to carve and sell small totem poles in Stanley Park. The rules against commercial vendors in the park were unofficially waived for them. In 1948 Ellen Neel was the featured speaker at a Conference on Native Indian Affairs held at the University of B.C., where she pointed out that rather than receiving handouts, Native people would much prefer opportunities to help themselves. The Park Board agreed and made it official: aboriginal artists could now sell their work in Stanley Park. Ellen Neel first sold her work from a teepee in at least two locations—the grassy area south of Brockton Point and Lumberman's Arch. Eventually she opened a large workshop at Ferguson Point where she carved with her family until 1951.

The Poles Since 1950

Over the years the park's collection of totem poles has changed, as has the location. Originally the first four poles were erected near Lumberman's Arch. These were then relocated to Second Beach, near the proposed "Indian village." When the village did not materialize, the poles went back to Lumberman's Arch. More poles were added to the site until 1962, when all had to be removed to make way for an overpass. By then, many of them were in poor condition, and the Skedans Pole fell apart when it was moved.

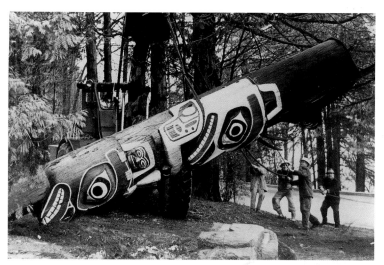

All of the totem poles needed major restoration work when they were moved from Lumberman's Arch in 1962. For many years the Haida mortuary pole had been patched with plaster and cement. It fell apart when being taken down, and the Park Board decided to have a replacement carved. Eric Lindsay photo, courtesy of the *Province* newspaper. City of Vancouver Archives, CVA 392-1063

The Haida carver Bill Reid and the Kwakwaka'wakw carver Doug Cranmer were hired to re-carve or restore various poles. Werner True, a university student, joined them and continued to work with Reid in carving a replica of the Haida mortuary pole. Doug Cranmer worked to restore the other poles. When the work was completed in 1963, all of the poles were erected at Brockton Point, where they stand to this day.

In 1986 Vancouver celebrated its Centennial, as well as hosting the world's fair, Expo 86. The dual celebration was an excellent opportunity to follow through on a new Park Board policy to replace or upgrade aging totem poles. All major B.C. and Canadian museums were assessed for restoration capabilities and display space. With funding from various sources, old poles were repaired and restored, and new and replica poles were carved over the next few years.

Several old poles—the Sisa-Kaulas pole, the Thunderbird house post, the Yakdzi pole and the Nhe-Is-Bik poles—were moved indoors; most went into museum collections. In exchange, Kwakwaka'wakw carver Tony Hunt was commissioned to complete a replica house post, and money was set aside to pay for a new Nisga'a pole by Norman Tait. The Royal British Columbia Museum contracted with Art Thompson, a Ditidaht (Nitinat) artist, and Tim Paul, a Hesquiat artist, to carve the park's first Nuu-chah-nulth-style pole. The Oscar Matilpi pole that had stood outside the Workers Compensation Board building in Richmond, a municipality south of Vancouver, was given to the Park.

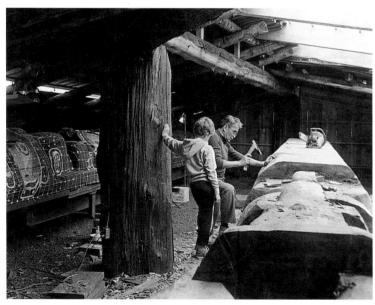

A young visitor watches as Kwakwaka'wakw carver Doug Cranmer works on an exact replica of the Wakas pole. The original rests off to the side, covered by a string grid to aid museum conservators in analyzing and matching traces of original paint.

SIWASH ROCK

Pauline Johnson relates the story of Siwash Rock, as told to her by a well-known Squamish leader, Joe S7ápele<u>k</u>, who was also known as Chief Joe Capilano. He explained that the column of grey stone, crowned by a tuft of green shrubbery, is a monument to the importance of keeping one's own life clean. The story tells of a handsome young chief who travelled north by canoe to find a northern girl and bring her home as his wife. Despite his youth, he had already proven himself a fearless warrior and excellent hunter. He was also true to the traditions of his ancestors.

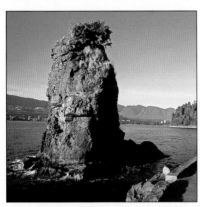

Photo by Al Harvey/slidefarm.com

When it came time for the birth of their first child, the young couple went bathing at Prospect Point to purify themselves. The wife then went ashore to give birth while her husband stayed in the water. After a while he encountered four super-natural giants in a canoe. They announced that they were agents of the Sagalie Tyee, or the Creator, and ordered him out of the water. The young man refused to obey, saying that he must continue his rituals so his child would be born to a pure life. Astounded by his defiance, the four were nonetheless impressed by his commitment and decided to turn the young chief into an inde-structible monument to clean fatherhood. As he waded to shore to greet his newborn child, he was transformed into the stone column we know as Siwash Rock.

In 1985 the Canadian Museum of Civilization agreed to fund the carving of a replica of the Wakas pole for the park in exchange for the long-term loan of the original, which had been deteriorating in the park for nearly 60 years. Doug Cranmer carved the replica pole, and after it was erected, he travelled back east to restore the original.

In the late 1990s, the Haida carver Don Yeomans re-carved the moon face on the Chief Skedans mortuary pole. The replica that Bill Reid had carved nearly 30 years earlier had been completely destroyed, so Yeomans worked from an old photograph to carve the face.

New landscaping has enhanced the Brockton Point totem pole site, and informative signs, a visitors' interpretive centre and gift shop have been added. The poles now get regular maintenance and painting, with historically accurate colours.

Today, eight million people visit Stanley Park each year—a success story that the city founders could scarcely have imagined. Now the challenge is to manage this success, maintaining the park for present and future generations.

E. PAULINE JOHNSON

Pauline Johnson was born in Ontario in 1861, the child of a noble Mohawk family on her father's side and an impoverished English gentlewoman. She proudly carried the name Tekahionwake. Pauline Johnson was a powerful performer, one of the most successful poets of her day and a lifelong champion of Canada's Native peoples. She made her living from a strenuous schedule of platform appearances in North America and Britain. A chance meeting in London with the Squamish leader, Chief Joe Capilano, blossomed into a close friendship when she settled in Vancouver. He introduced her to the customs and legends of the Squamish people, some of which she eventually published as *Legends of Vancouver*. The book sold 10,000 copies in her lifetime.

When Pauline Johnson died of breast cancer in 1913, the entire city mourned. Flags flew at half-mast, civic offices were closed and thousands of people lined Georgia Street to see her funeral cortege. By special arrangement, she was buried in Stanley Park. Pauline Johnson lies not far from Siwash Rock, which was made famous by her book.

The E. Pauline Johnson monument, erected in 1922,
is located near the Stanley Park Tea House.

Vancouver: Then and Now

The Lure of Gold

VANCOUVER MIGHT BE SAID TO HAVE BEGUN ON A WHIM. In 1858 the Native way of life on the mainland of British Columbia was disrupted by a gold rush along the Fraser River. The sudden influx of outsiders had far more impact than the fur trade of the past several decades.

Four years later, three young Englishmen who became known as "the three greenhorns" staked a claim for 550 out-of-the-way acres adjoining Burrard Inlet. The land did have a coal seam and a bed of clay, so they began making bricks. Today their "Brickmakers' Claim" encompasses the entire West End of Vancouver, and the green-horns are generally recognized as the city's first white settlers.

Others soon followed. A year later a Yankee investor, Sewell Prescott Moody, bought and revived a failing sawmill operation on the shores of what is now North Vancouver. Edward Stamp, an itinerant sea captain, opened a rival mill on the opposite shore in 1865. Soon both were loading logs and lumber onto sailing ships, destined for ports around the world.

The Growth of Settlements

Both Stamp's mill on the south shore of Burrard Inlet and the Pioneer Mill at Moodyville to the north drew settlers to the area, but neither offered any liquor. At the end of a long day's work, loggers, millworkers and ships' crewmen who were determined to get a drink regularly hiked or canoed to a new saloon opened in 1867 by John "Gassy Jack" Deighton.

The new settlement became known as Gastown, after its founder. In 1870 all six blocks of it were officially surveyed and named Granville Townsite. A jail, a post office and a school were soon added. The population was a mix of races, creeds and countries of origin, with some intermarriage between settlers and Native women. The common language was Chinook Jargon, a Northwest Coast trade pidgin.

Early photographs of settlement activity show tiny cabins surrounded by brush, stumps and felled trees. In the background stands the dark, ancient forest of cedar and fir. Travel throughout the area was slow and primarily by water. In 1874, daily steamboat service was set up between Gastown and New Westminster to the south;

a trip to the capital of Victoria on Vancouver Island took most of two days. All of this would change with the coming of the railway, promised to the new province of British Columbia on entering into the Canadian Confederation in 1871.

The Promised Railway

Beginning in late 1885, crews began clearing land, building bridges and laying track for the last stretch of the Canadian Pacific Railway (CPR) that would link the country, terminating at Burrard Inlet. The resultant economic boom represented a major shift from land with trees to land without trees—real estate.

From Settlement to City

The settlement suddenly became the focus for energy, land speculation and investment. In 1886, Granville was given royal assent to change its name and incorporate as the city of Vancouver. The new name was chosen to honour the British sea captain and marine explorer.

That same year, a "big fire" swept through the town's collection of clapboard buildings in less than an hour, but the blaze proved to be only a brief setback for Vancouver's determined citizens. By the end of a year of rebuilding, Vancouver could boast 14 office buildings, 23 hotels, 51 stores, 9 saloons, 1 mill, 1 church and a roller skating rink for its 8,000 inhabitants.

On May 23, 1887, crowds of eager citizens gathered at the new railway station to welcome the first "ocean to ocean" steam engine. The coming of the CPR heralded big changes for the young city, including the number of people coming to visit or stay.

The next year, 1888, Stanley Park was opened as the centerpiece for a city that just seemed to grow and grow. A controversial fresh-water line, laid in part through the Park (along what is now Pipeline Road), provided the young city with a reliable flow of fresh water. When completed in 1889, the pipeline improved firefighting capability, spawned the opening of new industries (such as a soda water factory) and restaurants, and immediately reduced the occurrence of typhoid.

The city developed culturally, as well, offering a library, a racetrack, two opera houses, the newly formed Vancouver Art Association, an amateur dramatic society and a Philharmonic Society.

The economic depression of the mid-1890s that settled over Canada, the U.S. and Europe, was cut short by the Klondike gold rush. It attracted thousands of people to the area and ensured Vancouver's continuing growth. The city rapidly opened schools and banks, established parks, built bridges, introduced electric lights and started a street railway with electric trams. Citizens enjoyed extended telephone service, 20 miles of graded roads and six miles of planked sidewalks, the first attempts at sewage control and completion of the Stanley Park driveway.

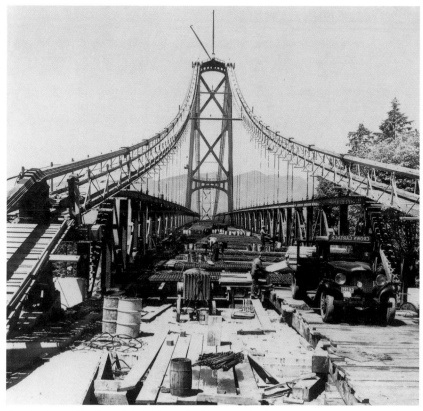

Construction of the Lions Gate Bridge in the late 1930s had a tremendous impact on Stanley Park and the City of Vancouver. As the population on the North Shore grew, so too did commuters' demands for an expanded highway that would take even more Park land. Vancouver Public Library, Special Collections, VPL 9631

Automobiles became common by 1900. The city's first 13-storey skyscraper was built, and harbour improvements were begun. In 1901, Vancouver had 27,000 registered citizens, and ambitious boosters predicted that the young city would soon have 100,000 inhabitants! By 1910, Vancouver had reached that seemingly impossible goal.

Construction of the Lions Gate Bridge in the 1930s was fiercely debated, but Vancouver was still suffering from record unemployment during the Great Depression and many felt this privately funded project would help. The new access road leading to the bridge opened up the most isolated and undeveloped region of Stanley Park. When completed, the bridge connected Vancouver with the North Shore, thus providing easy access to the vast real estate holdings of the syndicate that had funded the project.

The Metropolis

Today it's hard to tell where Vancouver ends and its suburbs begin. The population of Greater Vancouver has grown to just under 2 million, a mix of people from every corner of the globe.

In this sprawling urban expanse, one of the easiest ways to get a taste of the great forests that once carpeted the entire area is to stand surrounded by trees in Stanley Park. It is the legacy and reminder promised in a story in the Vancouver *News-Herald* on October 30, 1939:

> *A city that has been carved out of the forest should maintain somewhere within its boundaries evidence of what it once was, and so long as Stanley Park remains unspoiled that testimony to the giant trees which occupied the site of Vancouver in former days will remain.*

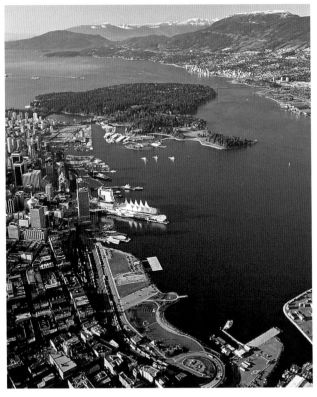

The forested peninsula of Stanley Park stands in stark contrast to houses, apartments, offices, shops and factories. As our population continues to grow, the challenge ahead will be to maintain the quality of Vancouver's parks and the region's natural resources.
Photo by Al Harvey/slidefarm.com

Further Reading on Totem Poles

Coull, Cheryl. *A Traveller's Guide to Aboriginal B.C.* Vancouver/Toronto: Whitecap Books, 1996.

Halpin, Marjorie. *Totem Poles: An Illustrated Guide.* Vancouver: UBC Press, 1981.

Jensen, Vickie. *Totem Pole Carving: Bringing a Log to Life.* Vancouver: Douglas & McIntyre, 1992.

Kramer, Pat. *Totem Poles: An Altitude SuperGuide.* Canmore, AB: Altitude Publishing, 1999.

Nuytten, Phil. *The Totem Carvers: Charlie James, Ellen Neel and Mungo Martin.* Vancouver: Panorama Publications, 1982.

Stewart, Hilary. *Cedar.* Vancouver: Douglas & McIntyre, 1984.

Stewart, Hilary. *Looking at Indian Art of the Northwest Coast.* Vancouver: Douglas & McIntyre, 1979.

Stewart, Hilary. *Looking at Totem Poles.* Vancouver: Douglas & McIntyre, 1993.

More Totem Pole Viewing Sites

The Northwest Coast area is a treasure trove of totem poles. Museums are often an excellent place to see numerous poles carved by First Nations artists, so check them out wherever you visit.

VANCOUVER AND AREA

In the Vancouver area there are totem poles at various locations, but start with these collections:

- The most visited totem pole grouping is at Brockton Point, in Stanley Park.

- UBC's Museum of Anthropology at 6393 NW Marine Drive houses a superb collection of poles. Look outside, as well, for their simulated Haida village.

- Smaller numbers of poles are located at VanDusen Gardens, in the Vancouver Museum, at the Plaza of Nations, in Horseshoe Bay Park, and at Capilano Mall and the Capilano Suspension Bridge in North Vancouver.

- The Vancouver International Airport has a cluster of well-carved totems outside the terminal and an excellent collection of large sculptural pieces at various locations inside.

VANCOUVER ISLAND

- In Victoria, the Royal B.C. Museum is a must-see with well-researched poles inside and outside. See the collection of poles in Thunderbird Park.

- Campbell River offers a variety of poles and Native art work, ranging from those at the Campbell River Museum to the large Wei Wai Kum Native mall. Take the short Quadra Island ferry ride to the Kwagiulth Musem on nearby Quadra Island.

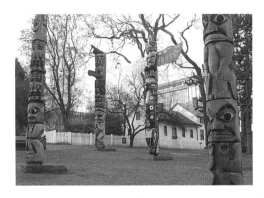

Thunderbird Park totems, Victoria, BC. Photo by Al Harvey/slidefarm.com

- Drive the "Route of the Totem" from Victoria to Port Hardy to see various poles carved during the 1960s. Other Vancouver Island totem sites along the way include Duncan, Nanaimo, Courtenay and Comox.

- Prince Rupert has an active museum as well as a city tour map of local totems.

OTHER SITES IN B.C.

There are great local museums and totem poles at these British Columbia travel destinations:

- Alert Bay's U'mista Cultural Centre and the restricted Nimpkish Cemetery offer examples of Kwakwaka'wakw poles as well as insights into the potlatch.

- Bella Coola is isolated but offers a few poles and an area of rare petroglyphs.

- Haida Gwaii (Queen Charlotte Islands) takes considerable travel planning but the old village sites are truly memorable. Note that Ninstints (Anthony Island) and Tanu are only accessible by boat or seaplane. Check out Skidegate, Old Masset and the Museum.

- 'Ksan is the reconstructed Gitxsan village near New Hazelton, but there are historic collections of poles in other Native villages in the area as well: Gitsegukla, Kitwanga, Kitwancool, Hazelton and Kispiox.

- The Nass River area has a growing number of new poles.

- Kitsumkalum near Terrace has newer poles as well as does Kitamaat Village near Kitimat.

SOUTH OF THE BORDER

- Seattle has fine totem pole viewing north of Pike Place Market and at other city locations. Don't forget the Thomas Burke Memorial Washington State Museum at the University of Washington.

NORTH OF THE BORDER

- Alaska is a melting pot of many different aboriginal cultures, but there are various collections of totem poles, museums and Native centers in Sitka, Ketchikan, Juneau and Wrangell.